Teach YOUR Child TO Draw

Bringing Out Your Child's
Talents and Appreciation for Art

Also by Mia Johnson:

Everything You Want to Know About Drawing and Painting

The Pink Heart and Other Tamperings

Teach YOUR Child TO Draw

Bringing Out Your Child's
Talents and Appreciation for Art

MIA JOHNSON

Photographs by ROB MELNYCHUK

LOWELL HOUSE
Los Angeles
CONTEMPORARY BOOKS
Chicago

Library of Congress Cataloging-in-Publication Data

Johnson, Mia.
 Teach your child to draw : bringing out your child's talents and appreciation for art / Mia Johnson ; photographs by Rob Melnychuk.
 p. cm.
 Includes index.
 ISBN 0-929923-25-1
 1. Drawing—Study and teaching (Elementary)
2. Drawing—Study and teaching (Secondary) I. Title.
NC615.J64 1990
741.2—dc20 90-6346
 CIP

Publisher: JACK ARTENSTEIN
Vice-President/Editor-in-Chief: JANICE GALLAGHER
Marketing Manager: ELIZABETH WOOD
Design: MIKE YAZZOLINO

Manufactured in the United States of America
10 9 8 7 6 5 4

The author would like to thank the following for their permission to reprint:

Chuck Close, *Phil/Fingerprint* II, 1978, stamp pad ink and pencil on paper, 29¾" X 22¼". Photo courtesy of The Pace Gallery.

David Hockney, "Bank, Palm Springs," 1968. Crayon, 14" X 17". © David HOckney, 1968. David Hockney, "Building Pershing Square, Los Angeles," 1964. Acrylic on canvas, 58" X 58". © David Hockney, 1964. David Hockney, "Japanese Rain on Canvas," 1972. Acrylic on canvas, 48" X 48". © David Hockney, 1972.

Thor Annual: TM & © 1989 Marvel Entertainment Group, Inc. All rights reserved.

Pablo Picasso, "Pigs," Charcoal, 8⁷⁄₁₆" X 10¹¹⁄₁₆". Courtesy of Courtauld Institute Galleries, London (Princes Gate Collection).

Charles Sheeler, "Feline Felicity," 1934. Conte crayon on white paper, 559mm X 457mm. Couresty of The Fogg Art Museum, Harvard University, Cambridge, Massachusetts, Louise E. Bettens Fund.

Vincent van Gogh, "Rocks with Trees, Montmajour," Pencil, Pen, reed pen, brown and black ink, 19¼" X 23⅝". Courtesy Vincent van Gogh Foundation/National Museum Vincent van Gogh, Amsterdam.

Vincent van Gogh, "View of the Rhone," pen and ink, 9" X 13¾". Courtesy Staatliche Graphische Sammlung, Munchen.

This book is dedicated to
The Three Blondes everywhere

With special thanks
to the children and parents of Los Angeles and Vancouver
who drew pictures for this book,
to super art teachers Don Aylen and Richard Lawrence,
and to my brother, Gary, who transcribed miles of notes.

Contents

"If you draw and dream that you can draw, then you can."

JESSE, age five

Who Me?
Teach My Child to Draw?

*T*each your child to draw? Of course! After all, who has ever taught him more than you have?

You have already taught your child so many different things. And yet, while you probably wouldn't hesitate to help him learn to speak or read or climb a tree, like many other parents you may feel that subjects such as art should be left to the "experts." Unfortunately, very few children have the opportunity to study under the guidance of art specialists. And even fewer teachers have the time to get to know your child as well as you do. If you enjoy doing things together, you can easily teach your child to draw.

As children readily demonstrate, the *desire* to draw probably has more to do with being able to draw than a "natural-born" talent. Being alongside your child, you can convey the most crucial message of all: that art is a significant and valuable activity. Moreover, this book has been designed as a "buddy program," so you too can learn and participate along with your child. If you don't already draw yourself, this book will teach you everything you need to know to convert your everyday activities into an art context and to help you show your child the wealth of visual material at his disposal.

How many things can you find to draw in one tree? There are hundreds of possible ideas in one tree.

HOW THIS BOOK WORKS

The ability to draw involves much more than a system or formula for drawing particular things. Drawing affects your child's senses, his perception, his mind and imagination, and his body. In her book *Drawing on the Right Side of the Brain,* Betty Edwards describes the process of exploring a tree. She writes, "This exploration may include touching, smelling, seeing from various angles, comparing one tree with another, imagining the inside of the tree and the parts underground, listening to the leaves, viewing the tree at different times of the day or during different seasons, planting its seeds, observing how other creatures—birds, moths, bugs—use the tree, and so on."

This kind of exploration is typical of the myriad approaches that artists take to their subject matter. Everything in an artist's environment and in his experience is a potential source for his work. The purpose of this book is to teach your child to *think* and *feel* like an artist and to translate his everyday experiences into drawing terms.

Each of the chapters in this book presents a new concept of drawing. You can help your child learn about ten important concepts that artists use: line, pattern, texture, light and dark, shading, negative and positive shapes, proportion, point of view, movement, and distance.

A brief introduction gives you, the parent, an understanding of the concept first and explains how to plan your teaching. It also describes common problems that children experience and typical ways they try to avoid or solve these problems. (You may recognize many of these devices from your child's current drawings.) The second section, "Helping Your Child Understand," shows you how to introduce concepts such as *line* or *pattern* to your child through dialogue, new vocabulary, and observation. The exercises in this section are active and sensory. The third section, "Looking at Choices," shows your child some styles and techniques used by real artists for applying each concept. He also examines subjects in your own home and researches subjects outside the home.

In the fourth section, "Using Concepts in Drawings," you help your child apply each new concept to his *own* drawings. He can begin with the activity games, field trips, or interesting research— using the home and environment as his resources—and then extend his research to preliminary drawings from life. These drawings are very simple and some will appear almost abstract, but they are based on a careful perception of reality. In "Drawing from Life," all the

concepts learned so far are brought together in knowing how to approach and draw real-life subjects. You will both be very proud of your results.

You will notice that there are no guidelines specified for the length of each exercise or discussion. While basically each exercise is meant to form a new session, at times you might find that two exercises or a discussion may easily be combined. This will depend on your child and his concentration level. One common time calculation suggested for any educational activity with children is to allow five minutes (or less) per year of your child's age before his attention wanes.

A section on "Trying Different Mediums" is included in several chapters. Ideas are given to help you and your child master techniques using different types of pens and pencils. And beginning in the second chapter, a new section called "Adding On" provides an accumulative summary. Here your child finds ideas for imaginative exercises that build on the concepts of all the preceding chapters. Each chapter ends with "The World Around Us," which suggests fun activities for making art a part of what you and your family do every day, whether you are eating, sleeping, bathing, dressing or entertaining.

There are more than 80 different ideas for drawing sessions in this book, and you can pick and choose the ones that interest you and your child the most. Depending on your child's age, you may find that some ideas are too simple and others are too advanced. You could give a child of any age a good, sound foundation of drawing skills in about two months if you were selective about the exercises. However, you could easily extend the ideas in this book over a period of two years because it is much more than a program of learning. You will find that it is full of experiences for your child's friends and family to share, for holidays, and for car trips. The drawing exercises range from large mural projects to field trips with sketch books. Experiences are also suggested for stores, galleries, museums, and for appreciating the world of graphics and commercial art. As your child gets older, you can do many of the exercises again in a new and advanced form because this book is designed to help parents with children of all ages.

HOW YOUR CHILD DEVELOPS ARTISTICALLY

Before beginning to draw with your child, you may find it helpful to take a closer look at your child's age-appropriate behavior and

abilities. You will find many suggestions for matching your child's practical and physical skills to art activities.

The Infant Under Two Years

The infant is still at a stage where sensory experience marks the beginning, middle, and end of his every experience. This fat red waxy thing? he wonders. He will want to smell the crayon, lick it, and chew it. Given a piece of paper, his uncontrolled grasp clenches the paper, and the nice crunchy sound encourages him to repeat his actions.

By coincidence one day the infant brings the two together, and he may be amazed at the mark that seems to have just appeared on the paper. He will continue to repeat the mark and eventually comprehend that he is making it himself.

Your child under two can be introduced to many weights and textures of paper and encouraged to make marks with sticks in the sand and dirt, with his fingers on steamy windows, and with soap crayons on the bathtub. He enjoys looking at paintings and feeling their texture, and gets very excited about photographs of people he knows.

The Two-Year-Old

At the age of two, drawing is a passionate physical activity. With crayon in fist, a two-year-old will attack the surface of the paper with great delight and physical energy. She will probably spend less than a minute drawing. Her crayon will frequently go off the paper and onto the table, or she will leave with it to try marks elsewhere in the room.

The first signs of activity awareness come as she begins to hold her paper in place with one hand as she draws with the other. As her physical dexterity grows, wrist movements help produce circular loops. She may begin to be selective about the crayon's color, although "color" is an advanced abstract concept that she will not fully comprehend for another year or two.

Age two is ideal for first introducing good work habits, such as preparing for a drawing time by sitting, standing at a chalkboard, or going to an easel; naming materials; thanking an adult for materials; or learning to brush the board and put crayons back in the box afterward.

You can avoid inappropriate drawing on walls and furniture by papering the whole table or wall, using chalks that dust off, or water-

From the earliest infant scribble . . .

soluble crayons and markers. A very young child cannot make a distinction between "a wrong drawing" and "a wrong place for drawing"!

The Three-Year-Old

The three-year-old is very busy learning manipulative skills such as those involved in the process of washing his hands and drying them. This is a good age for introducing art activities that require movement coordination and a sequence of steps, like removing and replacing crayons from a box of 12 or more; learning to use scissors or a hole puncher; cutting drawing paper into unusual shapes; or drawing outdoors with chalk. The three-year-old is apt to be more interested in the process than the goal, however, and may spend his entire time simply sorting the arrangement of colors in the crayon box.

His scribbling becomes better controlled as he develops a visual interest in his previously physically oriented marks. He begins to overlap his loops and repeat marks or add dots. He may repeatedly overlap a line until he goes right through the paper. It is important to present only one small idea a day, with much repetition, as his attention is generally elsewhere.

At the age of three, the average child can copy a circle and may begin to make radial shapes working clockwise or right to left. His preference for handedness, left or right, has now stabilized.

This is a good age to introduce the concept that art is valued, and your child should be encouraged to select pieces both for keeping and discarding.

The Four-Year-Old

By the age of four, most children can copy a square, and many will begin to draw purposeful lines and intersections. There is a parallel development between forms in drawing and forms in writing: children simultaneously reach the stage where they connect their drawing marks to objects in the world and alphabet letters to words as they are used in reading, writing, and speaking.

The four-year-old can sustain her concentration for up to 15 minutes, although the average is two-and-a-half minutes. She may begin to name her drawings, for example *Dog* or *Daddy Working,* as she explores the possibilities of shapes and learns to understand the relationship between herself and her environment.

At this age, the concept of continuing a project to the next day may be introduced, and she will retain a good memory for the steps

. . . to the emergence of purposeful lines at three years . . .

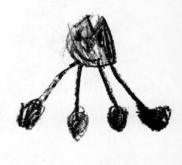

. . . and the beginning of figuration at age four.

involved in a new technique. It is unlikely, though, that she will recognize her drawing from a selection of drawings two or three days later.

If your four-year-old child has not yet been introduced to art galleries, she is now old enough to appreciate the concept of "keeping forever" important works of art.

The Five-Year-Old

The five-year-old is interested in the basic rules of social relations and the effect of his behavior on others. This is a good age for introducing art activities that involve him in a group goal.

The five-year-old has an adult grip on his crayon and may draw with a pencil in good detail. His marks have a definite purpose and meaning, and he may begin drawing recognizable representations. He can copy a triangle.

At this stage, your child might show a preference for making "designs" with elaborately repeated patterns of lines, grids, ladders, and radials. The first representations of figures are also developing, from circles with legs and eyes only to figures that have added-on limbs and body shapes different from the head shapes.

Your five-year-old is keenly aware of his own possessions, and this is a suitable age to present him with a small sketchbook or journal for drawing his "stories." He will also appreciate a picture frame with glass to exhibit a changing "picture of the week" of his own selection.

The Middle Years

The average child will continue to develop her own personal imagery and approaches to techniques, often creating amazingly detailed drawings of fancy women, super heroes, or space creatures by the age of eight. These will remain her own fantasy symbols, and she will probably embellish them for years to come. At the same time, you can teach her to expand her drawing vocabulary in the "real" world. After the age of five, and even earlier for many children, it is possible to introduce an entirely new "vocabulary" of drawing concepts and skills. Although the ability to draw the earliest configurations through to the first human shapes appears to be intuitive, *most later subjects need to be analyzed through observation and recording.*

Children over five can also be introduced to the idea of planning a drawing. Younger children tend to detail and "finish" each part of

This five-year-old has developed a system for drawing people.

A seven-year-old combines a wide variety of shapes and details in his drawings.

a drawing as they go rather than come back to it. Advanced drawing skills mean the ability to plan and develop the whole drawing one stage at a time, much like a photograph gradually exposing in a darkroom.

The cognitive development of your child in art is parallel to his development in math or science, and the extent of his capability for learning drawing skills and techniques in the middle years should not be underestimated. You will find that almost all of the activities in this book are interesting and suitable for children between five and nine years old.

The Older Child

The child over the age of nine or ten, or the preadolescent child, may eventually reach a stage not unlike that of the three-year-old: his attention is elsewhere. With few exceptions, his drawing skills have become confined to notebook embellishment, comic book heroes, "fashion" drawings, and a penchant for lettering. This is an age group that makes art teachers despair.

This is also an ideal age for introducing your child to some of the more practical functions of art in the world. He is very impressed by role models, and there are thousands of artists with open studios. Most galleries and museums have regular openings that are free to the public with the artist in attendance, and many artists offer talks on their work.

The older child is often very interested in learning how things work, and field trips can be taken to production houses to see the processes of assembly and pasteup, or to printing houses to see color posters or newspapers printed and assembled. In large cities it is often possible to arrange trips to movie production houses where backdrops and masks are produced; to see animation developed frame by frame; and to visit backstage at theaters to watch the unloading and assembly of props and backdrops for operas and rock concerts.

Preadolescence is also a good age at which to introduce the use of valuable art materials and equipment. A trip to a large art supply store to look at professional materials may lead to an interest in using calligraphic pens or Rapidographs, new types of surfaces such as scratchboard or illustration board, or advanced art equipment such as airbrushes and computer graphic programs.

Your older child will begin to narrow his interest in the *type* or *style* of art he prefers. Visiting galleries regularly one day a week or

Without guidance, the child in his middle years may decide that he "can't draw" and channel his imagination into elaborate costumes and finer detail.

With your help, he can begin to see the fluid lines of movement as his figures carve the air around them into shapes. (Adam, 17)

month to see similar work on display will reinforce his confidence and challenge his imagination. He may even choose one day to make a place for himself in the worlds of commercial or fine art. Meanwhile, he will have mastered a discipline that will teach him to concentrate, investigate, perfect, and complete tasks in many different fields.

WHAT YOU WILL NEED

1. A Time and Place

Your work area will need to seat the two of you comfortably, preferably side by side so you can easily discuss the same view of the subjects you draw. Most drawing is not messy and will not "run" so you can work on any flat surface, even the kitchen table.

It would be ideal if you could arrange a set time for drawing. This may be a time of day, a time of the week, or perhaps just a certain mood. It is more important that you are consistent in drawing *regularly* than it is for you to stick to a rigid schedule.

You will also feel a great sense of achievement if you can finish each lesson in turn and post or display your results as suggested.

2. A Display Area

Your display area should be permanent and in a highly visible area of the house where both family and visitors can enjoy and praise your efforts. A simple bulletin board with pushpins may be bought at stationery or art supply stores. Some kind of shelf or ledge below or alongside it can hold the subjects you have studied and drawn. You may find that a window and its sill will accommodate both your drawings and your objects.

3. Two File Folders Labeled with Your Names

These folders will hold your finished drawings after they have been displayed. If you label each drawing with the name of the chapter or the exercise, you will find it very helpful later to review your different sessions.

4. Two Sketchbooks Labeled with Your Names

Your sketchbooks should be quite small and manageable. These are

your *journals* to accommodate the overflow of ideas you will have between exercises. They may be taken along on field trips or car rides, and used for some of the exercises.

5. A Big Stack of White Paper

Any kind of white paper will do: a plain bond, typing paper, or artist's drawing paper. Buy a 50- or 100-sheet package, 8½-by-11 inches, and don't worry about wasting it. In addition to your participation, an infinite source of clean white paper is the greatest motivation you can offer a child.

6. A Jar of Sharpened Pencils and Felt Pens

Children love to draw with the most simple and basic tool—an ordinary pencil. They love the fine detail with which they can draw. Drawing with a felt pen, on the other hand, encourages your child to make very conscious decisions as he works.

Buy a number of regular pencils and two softer artist's pencils in an art supply store. You can find two fine-tip black felt pens in any drug store. Keep them in a special jar just for this work.

7. Two Erasers

Buy two white vinyl erasers in a stationery or art supply store, and keep them clean by trimming the crusts with a razor regularly. You will also use your erasers to actually "draw" in one of the exercises.

8. Special Materials

Some of the chapters will ask for other types of common paper and household materials, such as chalk, lemon juice, bleach, scissors, or a blackboard. You will find them described before each exercise, and alternatives are frequently suggested.

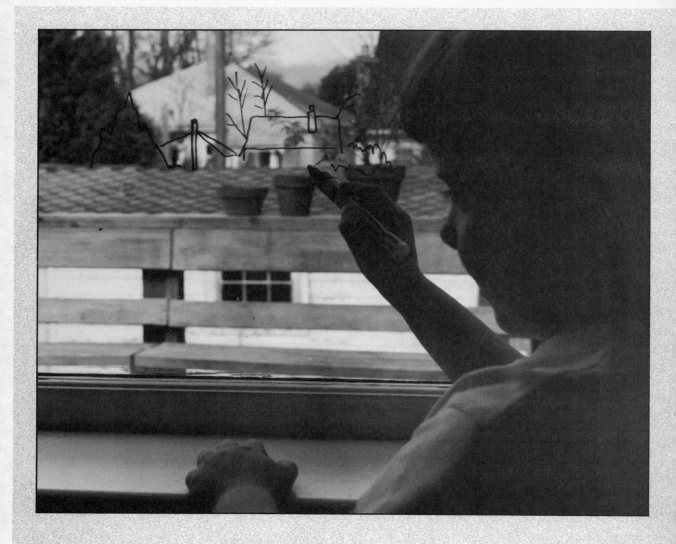

"You can see it in your mind, what it looks like, and then you can draw it."

AMARDEEP, age eight

1

Line

*T*his chapter introduces the idea that a drawing is different from the "real thing" that is drawn and that different choices can be made when you draw it. It also discusses how to begin thinking about lines that *work* or *don't work* in a drawing, rather than about lines that are "right."

When we draw, we inevitably use lines to make or suggest a picture. A line is the most basic element of drawing, in the same way that the alphabet provides a set of marks for making words. Even a very few carefully placed lines can hold a picture together and help it make sense as something recognizable.

Your child already knows this at an unconscious level, but he may have trouble placing those lines and making them come out right. A large part of his trouble may come from *seeing* the things he is drawing in a very limited way, and each chapter of this book will expand his ability to use all the elements involved in both seeing and drawing to help himself.

At the very heart of his trouble, however, may be a lack of understanding of the nature of drawing itself. He may not have made the crucial separation in his mind between seeing the object he is drawing and seeing the lines he is drawing as two *different things*. He may not understand that no matter how well he may draw a hand, he will not have a hand when he is finished: he will have only lines on a piece of paper that *stand for* a hand.

A line drawing can be detailed . . .

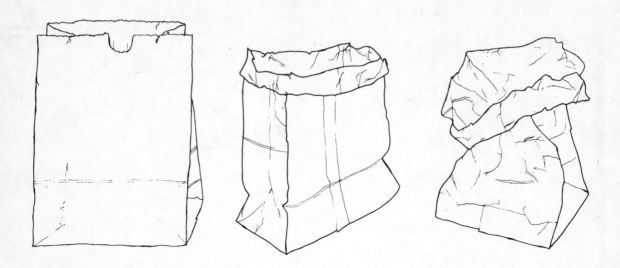

. . . or very simple. Fifteen-year-old Debbie has drawn a convincing paper bag with just a few lines.

This kind of separation is necessary before any real drawing can take place. Otherwise your child may continue to believe that there is one right way to draw the hand and feel very frustrated if he can't make the right lines. If you can help him learn that there are many different choices and methods for selecting the lines, he will soon begin to appreciate that drawing is a very *conscious* kind of activity and that he is the one in charge of the choices.

The following concepts and exercises are designed to help him become more conscious. You may want to start right at the beginning of the exercises, playing games with lines for their own sake, and then trying out different drawing mediums to make simple lines. The more advanced exercises suggest ways to use these lines in pictures. Your child will do a complete "landscape" drawing from life using a unique method of tracing reality to simulate lines for perspective, texture, and pattern. (By the last chapter, your child will know how to draw this same landscape without tracing it.)

HELPING YOUR CHILD UNDERSTAND LINE

A line drawing can suggest an outline of something, without having to shade in your subject to show roundness or depth or without having to draw a lot of details so that others will understand. A line drawing can be a very quick way of communicating with others, suggesting a lot more than is actually drawn. *But have you ever thought about how little a line drawing really has in common with reality?*

Try this with your child. Ask him to choose something in the room where you are now sitting and to make a simple line drawing of it. Watch as he draws, and notice how he has chosen to start. You will probably see that he begins with an outline that follows along the edges, and he will add some detail as he finishes.

Now ask him to look again at the subject he has drawn. Point to the lines in his drawing that show the edges of the subject, and ask him to go over and touch the edges of the real object. Ask him if he can see or feel a *pencil line* around them. He may seem a little confused by your question! Now ask him where he thinks the pencil lines came from. Did he imagine them? Were they an idea of his own? Praise him for having the good idea!

If your child is very young, you can go back a few more steps. You may have suggested to your child that he draw a large stuffed chair in the room, and, hearing the suggestion "chair," your child may have produced a drawing of a small wooden chair that bears no resemblance to it. You can then point to the lines in his drawing and ask him to find them in the big chair. Ask him if they are the same kinds of lines. Are they big enough lines or long enough? Let him try again, with lots of encouragement for paying attention to the "real" chair. (You will be doing many exercises in this book to help your child improve his ability to see things as they actually are.)

Help your child "see" the imaginary lines of the chair in the photograph on the left.

Figure 1: We have to *imagine* a line around the cat in this photograph.

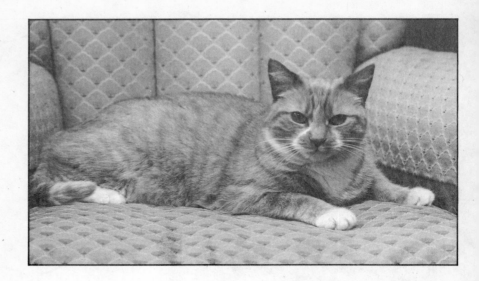

Figure 2: An expressive drawing of the cat uses a variety of lines.

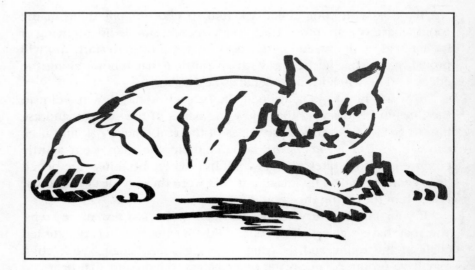

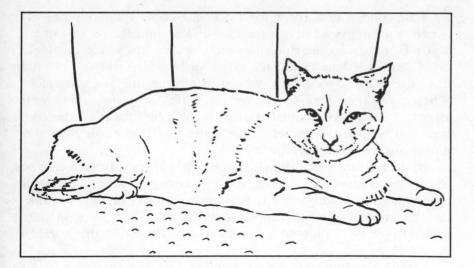

Figure 3: A simple contour drawing of the same cat has one almost continuous line.

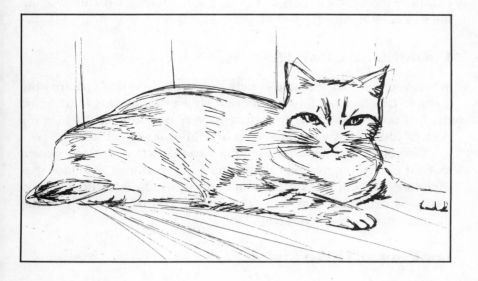

Figure 4: A loose sketch of the same cat has quick, overlapping lines.

This is not a hand. This is an arrangement of felt-pen lines on paper by Nancy, age 14.

Your child is now ready for a dialogue about the difference between real things and drawn things. Move around the room and ask him where he can imagine lines around the things that he might draw. Run your hand along the edges of furniture and say, "Would this edge make a good line? Where would the line start and stop? Where would we have to change direction?" The most important aspect of this activity is that you are helping him focus on the concept that lines are *artificial,* in the sense that *they come from our minds and not from real life.*

Be sure to do some drawings yourself, particularly of the same objects he is drawing, so that you can compare your choices for making lines. You will probably hear yourself referring to your drawings by saying quite odd things, such as, "Oh, you went in here before I did" or "I thought it was longer." Welcome to the world of drawing!

During the time you spend together before returning to your next drawing session, continue to reinforce the idea that things in the real world—like cars, houses, or cats—do not show up because they have lines drawn around them. Show him how we have to tell by their color, by their shape and size, or by their lightness and darkness where their edges stop and start before we can imagine lines to draw them.

LOOKING AT CHOICES

When you feel that the time is right, tell your child that you are now going to take a closer look at different choices for making lines. Since the first session may have introduced a very new kind of thinking for both of you, you may wish to begin here in your second session.

Your child now has a sense of the idea that when we draw we are making picture equivalents that stand for real things. Tell him that there are lots and lots of different ways to use lines to draw equivalents, as many different ways as there are people. Explain that the different ways are called "styles."

Looking at Three Styles

Here are three different choices of styles for drawing lines to represent the cat in the photograph (figure 1).

The first interpretation uses a wide variety of lines all in the same picture: long and short, curved or straight, hard, soft, or wavy. Have your child trace the lines of the cat in figure 2 with his finger and

imagine how it would feel to draw them. This is a very *expressive* style and quite typical of the ways lines are used by both young children and many mature artists.

If you have some of your child's earlier drawings at hand, look through them with him and point out all of the kinds of lines he has used. Again, have him feel the variety of lines he has used by tracing them with his finger. You can also praise him for putting lots of expression in his drawings by means of his lines. Tell him how the different lines make you feel when you point to them, such as happy, closed in, or like a storm is coming.

Beginning around age five or six, children begin to prefer a single line traced around the edges of shapes that shows fine detail where the edges go in and out. This kind of very clean and precise line is called a *contour* line. Explain that a contour means an edge, and hold up your left hand while you trace around its edges with your right forefinger to show its contours.

Have your child feel the clean and perfect contour line that goes around the edges of the cat in figure 3, and talk about which kind of look you each prefer. You can do this by asking him which drawing, figure 2 or 3, has the most expression and how each drawing makes him feel.

There is another common style of drawing lines, and it is called a *sketching* style. A sketching style looks like a series of loose, overlapping lines. Show him the lines of the cat in figure 4. Point out where some are long and some are short, but almost all are quick lines that often overlap. You can talk about different subjects that might suit this kind of drawing style, like long grass blowing in the wind or a man's beard.

Sum up the idea of styles by telling your child that there are many other styles of drawing lines, and each person will eventually develop his or her own individual look. Explain that we can often recognize an artist's work by the way he has drawn his lines because that artist really likes a particular style best and uses it for all his drawings.

At age three-and-a-half, Ian has carefully designed these lines.

Looking at an Artist's Drawing

The drawings of Vincent van Gogh have a very recognizable style. Van Gogh was a Dutch artist who worked in France 100 years ago for a very productive period of his life. Although he is best known for his paintings, he made 100 pen drawings like the one in figure 5 during a single year in France.

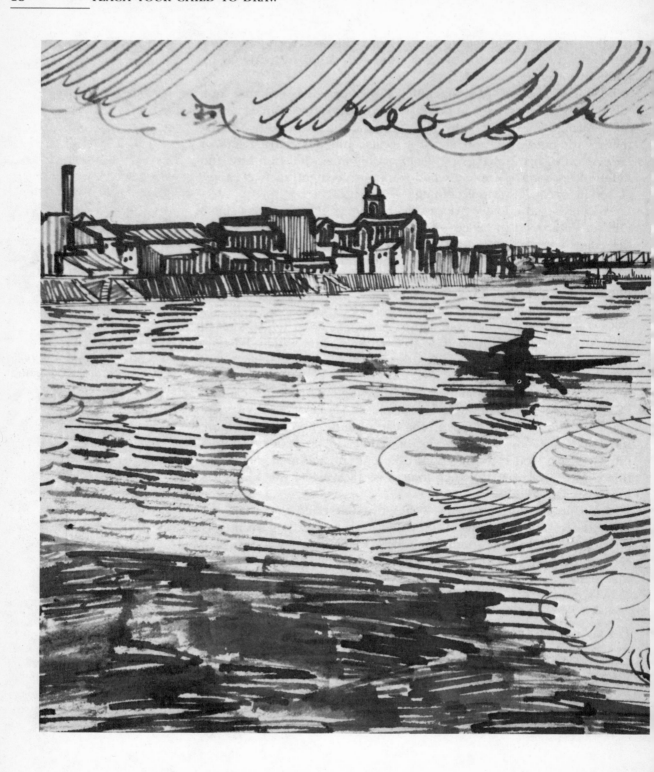

Both his drawings and his paintings have strong, repeated lines. If you look at them closely with your child, you can point out that they appear to be made up of dozens of long and short lines fitted together. He seldom shaded or blended his lines, so you can see each stroke clearly. Compare van Gogh's style with the sketching style in figure 4, and you will see that they have much in common. Both have very loose long and short lines, but van Gogh's lines don't overlap. Remind your child that this was a *choice* that he made, because he liked the look of separate lines.

In this pen drawing of a man fishing, van Gogh has used dozens of short lines at different angles to show clouds, buildings, and water. Your child can experience for himself how the artist felt when he made these choices. Hold your child's finger against each area, and have him rub the lines so that he can feel how the angles of the lines change. As he traces the *horizontal* (sideways) lines of the water, ask him if he thinks it "feels" like water. If he seems interested, you can lay a piece of paper over the water section of van Gogh's drawing, trace the boat, and then surround it with lots of short *vertical* (up and down) lines. Ask him if the lines you have drawn still "feel" like lines that stand for water, and he may say yes but "more like a waterfall than the sea" or "like it's raining." This exercise gives you a good opportunity to demonstrate how the same style of drawing can be used to stand for different things.

Your child may feel eager to choose his own style now. You can remind him that the purpose of the book is to give him lots of ideas for choices so he can do just that.

USING LINES IN DRAWINGS

For the following four exercises, you can make a set of 32 samples of different kinds of lines to play drawing games with your child. Preschoolers especially will love to sort these samples.

To make the samples, fold a piece of 8½-by-11-inch paper in half the long way, then in half the long way again. Open it flat.

Now fold the short sides in half, then in half again. Open, and you will see the outlines of 16 rectangles.

Repeat this with a second piece of paper. You will have 32 rectangles in all.

With a black felt pen, draw the eight kinds of lines in figure 6 four times each. Draw each one in the middle of a rectangle.

Then cut along all folds.

Figure 5: *View of the Rhone,* Vincent van Gogh, pen and ink. (Detail)

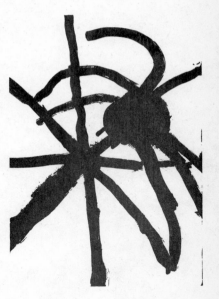

When children first learn to paint, they continue to "draw" lines with the brush. This design of radiating lines by five-year-old Jesse has near-perfect symmetry.

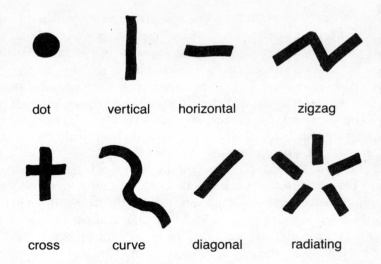

Figure 6: You will have four copies of each of these lines and shapes.

dot vertical horizontal zigzag

cross curve diagonal radiating

1. Recognizing and Naming Lines

Even a very young child can learn to recognize different kinds of lines by sorting your predrawn samples.

Shuffle the 32 rectangles and have him sort them into eight matching piles. Talk about what makes the lines different and how to tell them apart by referring to the *size* and *directions* of the lines.

You can use words such as *longer* or *shorter, bigger* or *smaller, sideways* or *up and down.* With the older child, you can use *horizontal* for sideways, *vertical* for up and down, or *diagonal* for lines on an angle. You could point out that a cross is made from a horizontal line and a vertical line. You may wish to add some of your own line samples and help him make up more expressive names for them, such as *skinny, dark, wandering, broken,* or *sketchy.*

2. Feeling and Imagining Lines

Shuffle the rectangles and turn them upside down. Look at the first one without showing him and then draw it with your finger on his back. Ask him to guess, in his own words, which one it was. Then show him the sample and reinforce his vocabulary for describing it.

You can do a few more before letting him choose one to draw on your back. Take your time with your descriptions of the lines he is drawing. You might say something like, "You are pressing very lightly so that must be a very skinny line, or maybe a light line. . . . Now it's broken . . . and you've crossed over it with a heavy horizontal line. . . ."

3. Using Lines

Watch your child for a sign that the games are becoming too easy for him! Here are some ideas for extending these exercises.

Have him draw these eight kinds of lines on paper or make a picture putting together only these kinds of lines. Try to think of subjects that use different combinations of lines, such as crosses for ladders or curved lines for bananas. For example, ask what he can draw with a zigzag line and a curve. Ask what kinds of lines he would use to draw a flower or to draw rain. Have him suggest subjects for you to draw, and talk about the kinds of lines you choose for drawing them.

For a good exercise in concentration, you can make a line drawing on his *back* and have him "guess" by drawing it on *paper.* Take turns, and encourage him to draw slowly and steadily on your back. You might decide to limit yourselves to a category like animals and make simple line drawings of cats, elephants, giraffes, and others. Talk about the kinds of lines that *work:* long, straight vertical lines for a giraffe's legs, two curved lines for an elephant's trunk, and so on.

You can also practice drawing different kinds of lines with chalk on the sidewalk. This will give your child a nice change of environment. Talking about the "feel" of the chalk on cement will be a helpful transition to your next session when you will experiment with different mediums.

From this point on when your child shows you his drawings, use good feedback words to describe how he has used his lines. For example, "I like all the different *angles* you have used to draw the house and the *short quick* lines here for the grass. Your clouds are nice and *curvy."* Use these kinds of words to talk about his lines even when you are not sure of the subjects of his drawings. You may feel awkward at first, but your child will be very pleased at your choice of expressive words.

TRYING DIFFERENT MEDIUMS

In the chapters that follow, you will be using a wide variety of mediums to draw everything from pattern and texture to shadow and motion. The line exercises in this section give you and your child a chance to try out many of these mediums beforehand.

Tell your child that just as there is no "right" drawing *style,* there is no "right" drawing *medium.* A drawing medium can be anything: a simple pencil, an artist's soft black pencil, a felt pen or a writing pen, a piece of charcoal, or a crayon—even a stick used to draw in the

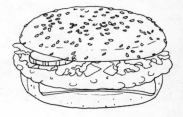

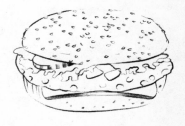

Compare the effects of the same hamburger drawn in two different mediums: a felt pen (top) and a pencil (bottom). Which is softer? Which one has more detail?

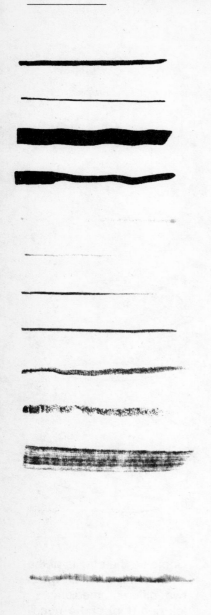

Figure 7: Can you match these lines with your own mediums?

sand. A drawing medium is anything you put in your hand (or foot or mouth) and use to make marks. Describe all the possible kinds of drawing mediums you can think of to your child, then enlist his help in rounding up as many as you can find in your home.

Both you and your child will have personal preferences for how the mediums *feel* when you make marks. Different papers can affect how a medium feels. A felt pen will glide over smooth paper, but may feel rough and unpleasant on textured paper. The size and shape of the pen or pencil in your hand may affect a style, too. A fine pencil may make you or your child feel more expressive or make you want to put detail in your drawing. A large felt pen or crayon may lead you to use simple contour lines or to sketch.

In the following exercise, you and your child can explore the use of the drawing mediums you have collected. While guidelines are given, have some fun with your own ideas. You will not be drawing any particular "thing," and you should encourage your child to be as experimental as he wishes.

Trying Out Lines

Begin with a piece of white bond paper for each of you and one drawing medium each. Copy the types of lines shown in figure 7, using all of the mediums you have collected. If possible, try them on several kinds of paper and again compare their look and feel on the different surfaces. You could use words like *softer, rougher, smoother, finer,* or *blacker* to describe the appearance of the lines.

Ask your child to help you choose some of his drawings for the display board, and put the drawing mediums on the shelf under it. Your child will love to ask family members and visitors to match the mediums with the lines he has drawn.

DRAWING FROM LIFE

At this point, the child who has been asking, "But Mommy, when are we going to learn to draw?" can be reassured that he is already learning a lot about how artists *think* when they are drawing. The purpose of the final exercise in this chapter is to now help your child *see* and *draw* these kinds of lines in a view of the world that he has chosen.

Your child will be drawing a landscape view directly on a window with a felt pen and tracing his view with lines that are appropriate for each subject. The tracing process will give him a good ap-

proximation of how he will feel later on drawing directly from life without tracing.

It will also give him confidence in his ability to see lines, to choose ways of drawing them, and to practice the kind of concentration that drawing from life demands.

1. Choosing a View

Begin by telling him that he is going to choose a view out the window that he would like to draw. Look out each window of your house or apartment in turn, and talk about what you see.

Help him pick a view with subjects that afford a wide variety of lines; for example, *vertical* straight lines, such as the edges of buildings and telephone poles; *diagonal* lines made by the edges of streets, sidewalks, and staircases; *horizontal* lines, such as fences and telephone wires; *curved* lines along mountain edges or clouds; *short* lines for texture, such as grass and leaves; and *patterns* of lines seen in checkered patio tiles or roof shingles. Be sure to pick a view which will remain stationary: a street full of moving traffic would be an impossible subject!

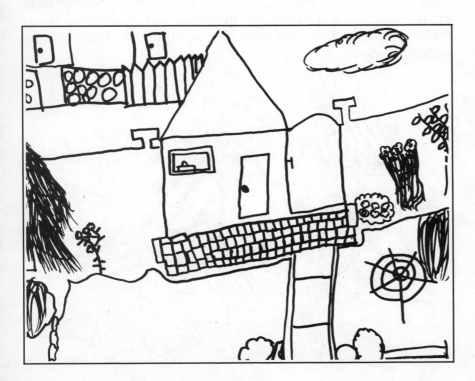

Nine-year-old Crystal has found many kinds of lines and patterns in this view out her window. How many kinds can you identify?

2. Choosing a Pen

Your child will need a fine-tip black felt pen that is water-soluble (washable). Try out pens by writing on your fingernail and see if the ink rubs off easily. When your child has finished his drawing, you can wash the window.

3. Drawing a View

Have your child stand at the window, looking at the view he has chosen. Stand directly behind him and squat down so your eyes are at the same level as his.

Hold his finger and have him trace the kinds of lines described above on the window *with his finger first.* Have him feel the different directions and lengths.

He will find that for the lines to remain stationary, he will have to stand perfectly still and look at the view *with one eye only.* If he changes eyes, the subjects he is tracing will appear to jump sideways. This happens because each eye actually sees from a slightly different angle. When we look with both eyes, the two angles merge and make sense. However, it is impossible to trace using both eyes. Your child can try to keep one eye closed for the duration of his drawing, or you could cover one of his eyes with your hand to block out the other angle he is seeing.

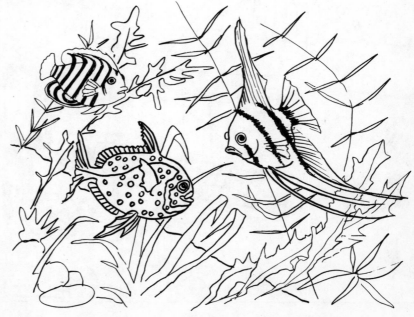

Two ten-year-olds have used more than 100 diagonal lines in their joint drawing of fish. How many diagonals can you see?

Once he has identified many different kinds of lines, he can use the felt pen to draw them directly onto the window. Suggest that he draw all the *long lines first,* so they can be his reference for the shorter lines and so he won't lose his place. He should also rest his drawing eye at intervals. Encourage him to draw slowly and carefully; it may take him 15 minutes or more to complete a window drawing twelve by eighteen inches. (See photograph, chapter opening page.)

You may both be surprised at how small the drawing is. Although distance decreases the size of subjects dramatically, we are seldom aware of this phenomenon unless we have a really unusual vantage point, like from the top of a skyscraper. Talk about this illusion of distance with your child. Have him close one eye and use his thumb and forefinger to measure objects that are within a foot of him in the room. Then have him walk backwards and see how quickly their size, measured still by his thumb and forefinger, decreases.

When he has finished drawing his view on the window, he could "save" it by tracing it on a piece of paper taped to the window over his drawing. He might like to add more detail or color to this drawing with felt pens or colored pencils.

Your child has now had a "real" experience drawing from life, and subsequent chapters will give him the information he needs to draw *without* tracing. Encourage your child to trace as many drawings on the window as he wishes because the degree of concentration he masters through this process will be invaluable. When he draws smaller objects with difficult perspective, like the roller skate in figure 8, he can use a piece of glass propped on the table in front of him to help him see the lines.

Figure 8: Practice tracing smaller objects on a piece of picture glass to help you see their lines.

THE WORLD AROUND US

During the days which follow, try one or both of these activities to reinforce the new ideas about lines.

1. Making a Jigsaw Puzzle

Make a jigsaw puzzle that will help your child learn to recognize and match different kinds of lines.

Start by gluing a page from a coloring book onto a thin cardboard backing. Coloring books are recommended because the drawings are clear and simple. Then use carbon paper to transfer the jigsaw puzzle outline provided in figure 9 right onto the coloring book picture, and cut the puzzle into pieces.

Figure 9

Help your child reassemble the pieces by matching the lines. Talk about the different directions or angles the lines take, and notice the "clues" that you had for matching the lines up. For instance, you might point out that a curved line on one piece continues in a curve on another piece.

2. Seeing Ready-made Lines

Look for real lines as you drive; for example, solid yellow lines and broken white lines painted on the street; crosswalk lines; or power wire lines. Talk about what they mean.

Encourage your child to become conscious of these "ready-made" lines of all kinds wherever he goes, and to imagine how he could use them in a drawing.

You could also ask your child if he would like to go on a field trip with your journals and make drawings of street intersections with road and power lines. Use words like *horizontal, vertical,* and *diagonal* to describe the lines that you draw. You can use figures 10 and 11 as a starting point for these activities.

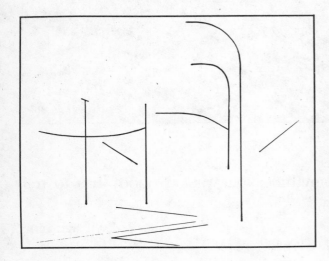

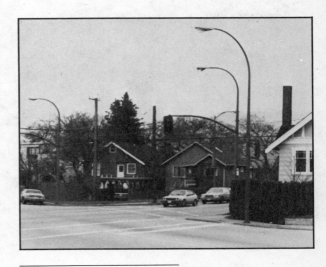

Figure 10: Can you identify all the lines in this diagram? Compare it to the photograph for clues.

Figure 11: Photograph of a streetcorner

"You can draw anything you want. Nobody has to tell you what to draw."

PAUL, age nine

2

Pattern

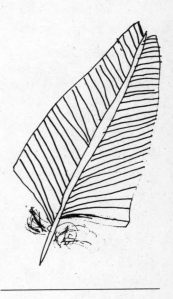

Soon after they begin to draw lines, children realize that lines and shapes can be repeated to make *patterns*. Making patterns seems to be an activity that comes very easily to them, and they will impose patterns on their drawings, around their drawings, or even choose to draw patterns instead of drawing real objects.

This process, however, appears to be very arbitrary. Drawings by young children are often filled with patterns of stars and hearts, for example, which appear to have no meaning other than to decorate or fill space. The important link between the patterns themselves and the subjects they draw, or the *reason* for the patterns, seems to be missing. Children are also rarely conscious of the ready-made patterns that can be found in the world around them and miss many opportunities for expanding their vocabulary for making patterns. Instead, similar stereotyped motifs are widely used.

The exercises in this chapter show your child that pattern is one more aspect of the visual wealth available around her, and they will help her appreciate the concept of pattern as it is incorporated into drawings by artists.

This chapter also provides a good transition to the third chapter, when your child will learn to repeat lines and patterns to make drawings of texture.

Seven-year-old Andrew has paid close attention to the realistic pattern of diagonal lines in this feather drawing.

This six-year-old has already picked up stereotyped motifs of hearts and stars, which he has used to decorate his anteater.

Figure 12: How many line samples from page 20 can you find in this border pattern? How many times is each one repeated?

HELPING YOUR CHILD UNDERSTAND PATTERN

The two elements of pattern are *motif* and *repetition.* A motif is simply any single kind of line or shape, such as a zigzag, a dot, a star, or a flower, that repeats itself. Most patterns use two or more motifs arranged in a design where they usually alternate with one another. The spacing of the motifs is very regular or *symmetrical.* Sometimes motifs are lined up in rows or borders to decorate edges, and sometimes they are used to decorate whole areas.

In this section you will open up a dialogue with your child about what she already thinks a pattern is and then introduce the concepts of motif and repetition. This initial section on looking at the elements of pattern would make a good session by itself.

Start by suggesting, "Let's not draw anything today; let's just make patterns." Ask her, "Do you know what a pattern is?" and begin making some doodles of any pattern that comes to your mind. Encourage her to doodle on a separate paper. You will probably find yourself looking at haphazard arrangements of marks on your papers! Tell your child, "These are good patterns," and ask her if she can think of some ways to use them to decorate something. For example, at this point she may want to draw a border around the edges of her paper and choose some of her marks to repeat. You could even refer her back to the line samples you drew in chapter 1 to use variations of crosses, dots, zigzags, and so on (see page 20).

Once your child is involved with this activity, explain that patterns always alternate marks: "First one, and then another, then the first one again, then another." Point out that patterns are always spaced evenly, or *symmetrically,* and help her use her finger or pencil to "feel" the spacing between the marks by hopping from one to another. You can also talk about different ways of alternating the marks; for example, doubled up, repeated individually, leaving extra spaces between them, and so on.

Begin to use the word *motif* in your vocabulary here, and tell her that each kind of mark she has chosen is another motif. Talk about repeating and alternating motifs. At this point you could focus more on the concept of motif itself. Suggest that you make up some motifs that stand for simple objects, for example, a leaf, a moon, a flower, a

fish, or a pineapple. Help your child simplify her motif so it is easy to draw and to repeat. If your child is enjoying this activity, put on some quiet music and continue making up patterns and talking about them.

LOOKING AT CHOICES

Looking at Traditional Motifs and Patterns

Your child will be interested to learn that people all over the world have designed motifs and made patterns with them since the beginning of time. Show her the three common motifs in figure 13, and tell her that they are very typical of the styles of motifs made by people in these cultures.

You can point out how the flower motifs from China, Japan, and Hawaii differ. For example, the Chinese motif uses *one contour line* to trace around the curves of each flower section. Have her run her finger around the lines. Then show her how the Japanese motif uses *areas of light and dark* for contrast instead of using a line, and have her point to the different areas. Explain that the Hawaiian motif uses line patterns for veins *as well as* using both a line outline *and* areas of light and dark, so it is the most detailed, or realistic. You may want to have a real flower nearby for comparison.

Most cultures have their own personal motifs and combine them to make identifiable patterns. The patterns are handed down through the generations and become traditional. Tell your child that there are thousands of traditional patterns in the world and that they all have names. You can look at each of the traditional patterns in figures 14–16 together, and talk about the kinds of motifs that are used.

For example, the Scottish plaid uses patterns of *horizontal* and *vertical* lines crossing each other to make boxes. Show her where the boxes alternate areas of light and dark. The American Navajo design uses *zigzag* lines to make patterns of light and dark zigzag shapes. You can have her feel the spaces.

Pennsylvania Dutch patterns alternate simple *pictures* of real things such as hearts, tulips, and little people. Point out the spacing of the pictures in figure 16 and show her how it is very even or symmetrical. She can count the number of different motifs in this example.

You will probably have patterns throughout your own home, and many may be traditional. You child will love to look through the kitchen and dining room cupboards for examples of patterned

1. A Chinese flower motif with a contour line.

2. A Japanese flower motif with contrast.

3. A Hawaiian flower motif with line patterns and contrast.

Figure 13

Figure 14: A Scottish plaid has patterns of lines.

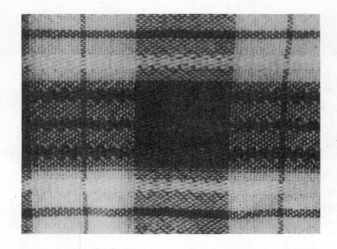

Figure 15: An American Navajo design has patterns of zigzag shapes.

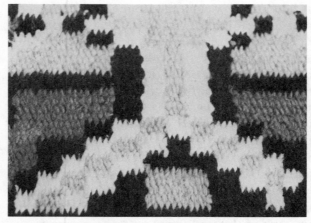

Figure 16: A Pennsylvania Dutch design has patterns of pictures. How many picture motifs can you see?

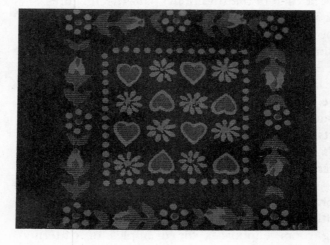

dishes. You can point out patterns in your rugs, curtains, sheets, wallpaper, or blankets as well as those on clothing, giftwrap, or bookcovers. She may find some examples of border designs in your home in addition to all-over patterns. Remind her that a pattern can be as simple as lines repeated to make stripes.

You can learn more about traditional patterns if you and your child visit an antique shop, a country store, a china department, or a foreign import store. Ask the salespeople to tell you the names of patterns you find and their countries of origin. Examine the motifs and their arrangement with your child; look for patterns made with *lines, shapes,* and *pictures.*

Looking at Patterns in Nature

At this point you can introduce the idea that there are also readymade patterns to be found everywhere in nature, and that artists learn to see them and make choices about how to use them in their drawings.

Begin by looking at the patterns in figure 17. Tell your child that the artist got the ideas for each of these patterns from nature. Ask your child to tell you what she thinks each pattern is. None of the answers your child gives is wrong; in fact, she may be seeing a pattern quite creatively. Tell her that if she is interested, the artist wrote down the subjects he was thinking of when he drew them and that you will tell her after she has guessed. Examine each illustration with your child and find the lines or shapes that are repeated in each.

There are many examples of natural patterns in the world around us. You can explain that an artist's eye is always alert to the potential of these ready-made patterns, both small and large. An artist could use cloud patterns to create a feeling of stripes, trees to create fan shapes, or water ripples to form a target pattern.

Looking at an Artist's Drawing

David Hockney is an artist who loves to use patterns. Hockney is a British artist who has lived and worked in California. He has a very keen and observant eye for the patterns in his surroundings, particularly patterns made by water. He is famous for his pictures of swimming pools with patterns of curved lines on their surfaces and for the fan shapes he creates with sprinklers, fountains, and showers.

Figure 17: Can you guess these patterns found in nature?
Figure 17 answers:

1. Fur: overlapping diagonal lines.
2. Wood: curving parallel lines.
3. Feathers: a repeated shape.
4. Evergreen needles: radiating lines.

Nine-year-old Harkamal created this pattern by repeating a cloud, a skyscraper, and diagonal lines for rain.

This graceful flower design was found repeated in her upholstery pattern. Phyllis, mother.

Show your child how Hockney has used the same kind of pattern he found in nature to make the two different drawings of palm trees in figures 18 and 19. In both of them, he is using the *motif* of a palm tree repeated in a *row* to make a design of *stripes*. In figure 18, the palm trees are dark and the wall is light. In figure 19, he has drawn light palm trees against a dark wall.

Take the opportunity to ask your child which one she likes better, and why. You could ask her how each drawing makes her feel. Is the weather hot or cold? What time of day might it be in each drawing? Which street would she prefer to walk down?

If your child is very young, you may find it enough to simply introduce the idea that *the artist has used the trees like stripes.*

USING PATTERNS IN DRAWINGS

For these exercises, you will prepare a puzzle using *patterns* for your child. Find five small remnants, each about eight by twelve inches, of cloth or paper that has repeated patterns. To help your child focus on the concept of pattern rather than color, try to find remnants with very similar coloring, or run all the remnants through a copier and cut up the black-and-white copies. Scraps of giftwrap or cloth that have large, bold patterns would be ideal. Cut each one into pieces about four inches square. You will have 30 pieces in all.

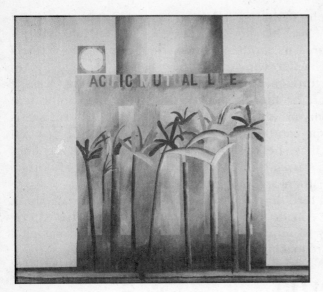

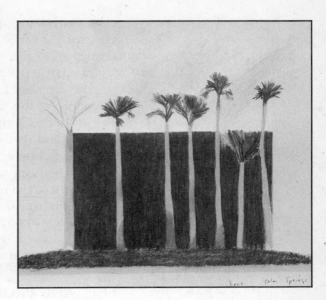

1. Recognizing Patterns

Shuffle the 30 pieces and have your child sort them back into the five piles of patterns that match.

Ask your child to describe how she knew each pile matched. She might say, for example, "I could see these stripes were bigger" or "All of these pieces had this little dot thing." Where possible, reinforce her vocabulary for describing the kinds of lines and patterns she saw as clues. Use words like *wide* and *narrow, horizontal, diagonal,* and *vertical, straight* and *curved,* and *longer* and *shorter.*

2. Matching Patterns

Have your child rearrange each of the five matching piles into the original eight-by-twelve-inch pieces. She will have to match patterns using both lines and solids as her guide and try to line up very similar-looking shapes.

Keep these pattern "puzzles" for the future, as she may enjoy doing them again with her friends or together with a younger child.

3. Using Patterns

Suggest to your child that she draw a bird and decorate it with patterns copied from these remnants. Tell her that she can be realistic or that she can draw a fantasy bird. Try to find a book with good

Figure 18: *Building, Pershing Square, Los Angeles,* David Hockney, acrylic on canvas. (Left)

Figure 19: *Bank, Palm Springs,* David Hockney, crayon. (Right)

Eight-year-old Josh shows an appreciation of the concept of pattern here, but he has not yet applied it to the different sizes and directions of "real" feathers.

Although this is a fantasy drawing of a bird, ten-year-old Nicky has used realistic changes in the size and directions of his patterns.

close-up photographs of birds, and have her look at the different areas of the birds. Show her how the directions of feather patterns change from one area to another or how the scale of the feathers might change from back to wing to tail.

She can search through your remnants for good patterns that she can apply as they are or alter to suit the areas. The most important aspects of this activity are that she is conscious of the patterns she is applying and that she can begin to *reason* her choices. She may tell you, for example, that she is using repeated rows of zigzag lines around the neck to "make the bird look ruffled" or areas of dots to show "where the feathers are really short."

Be sure to do a bird drawing yourself so that you can talk about the choices you have made for your motifs and patterns. This will be a good opportunity to remind her that you are not really making a bird, but that you are making artist's choices.

DRAWING FROM LIFE

In this exercise, your child can make drawings of subjects that have line patterns, and she can post them on your display board for family members to guess their origins.

Drawing Subjects with Ready-made Patterns of Lines

Before she begins to draw, help her become familiar with each subject. Encourage her to run her hands along the grooves of a radiator, for example, or feel the raised veins on the backside of a leaf. Help her first *imagine* the kinds of lines she will make to draw it and to see how the lines are repeated.

To do this, you can talk about the size and dimensions of each subject. For example, if she is looking at a comb, point out how each tooth is wider at the bottom than at the top, and ask her how far apart she thinks each tooth is. Ask her if the lines of the teeth are parallel or vertical and how many teeth there are. She can even count the teeth to give her a realistic idea. *You are helping her become more conscious of the patterns she sees, so that she can draw them more accurately.* These are typical of the kinds of calculations that an artist would make, except that he may do them so quickly that he is barely aware of them.

Help her find each kind of pattern in turn, and sit with her while she "collects" each subject by drawing it. Either a felt pen or a pencil would be suitable.

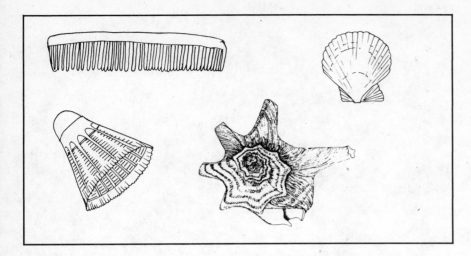

1. Parallel lines found in a comb by a six-year-old.
2. Grid pattern in a badminton bird.
3. A radiating design in a shell by a sixteen-year-old.
4. Fan pattern in a clam shell.

Some suggestions for subjects with line patterns are:

1. Parallel lines in feathers or the teeth of combs.
2. Grids in ventilator panels of home appliances or in cookware.
3. Radiating lines such as daisy petals or spider webs.
4. Fans found as lines within shapes, like the veins of leaves or the grooves in clam shells.

ADDING ON

Making an Abstract Design

With a black felt pen, you can each make a fantasy line drawing, then pattern each area with motifs taken from nature. Try to include patterns of lines, patterns of shapes, and patterns of light and dark. You may wish to limit yourselves to patterns found in flowers, leaves, vines, and roots.

You could have a "nature hunt" for your ideas, or take a trip to the library as a resource for books that contain ideas for organic patterns. Try the biology section for books with photographs taken through a microscope that show the organic patterns "hidden" in plants and animals. Even better, try to borrow a microscope and slides of cell structures to look at patterns firsthand.

Your child may need help planning a structure of line shapes. Although this is a very free-form exercise, children often rush their planning to get on with the patterning. You could have your child do a rough copy of the line shapes first and use it underneath a new paper.

Figure 20: How many different patterns can you find in this fantasy abstract by fourteen-year-old Cory? There are at least 10. Compare them to patterns found in nature.

Nine-year-old Sandeep used five different line patterns to draw the treetops and tree trunks, the water under the bridge, footprints, and the sun rays. Can you identify all the motifs?

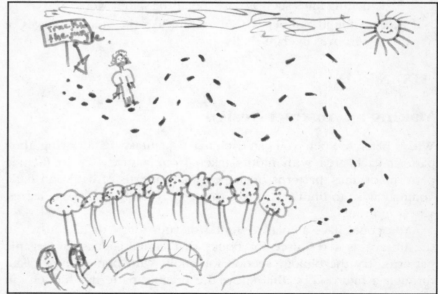

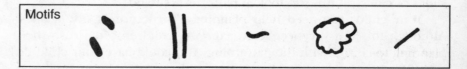

Motifs

Figure 20 shows the results of one fourteen-year-old's drawing, but even children as young as six will love to do this and have good results.

THE WORLD AROUND US

You can choose one or more of these ideas for extending the concepts of pattern into your daily life. Nature is full of patterns and places to make patterns.

1. Patterning Your World

Wherever you go and whatever the weather, draw patterns with your child. Here are some ideas for patterning your world:

Draw snowflake patterns on a steamy window with your fingers or make a pattern for rain on the window.

Draw patterns of waves or birds in the sand with sticks.

Make patterns of giant bird or animal tracks in the snow with your feet. Balancing on one foot, use your other foot to make a fan shape of three footprints with the heels touching (then alternate feet for the next print), or hop with both heels together and your toes in a V position.

Decorate the edges of your journals with border patterns.

Have your child use bathtub crayons to customize your tub with patterns.

On a long rainy day, let your child design a border around the baseboard of her room with washable felt pens.

2. Making A Personal Motif

Use your journals to plan a "personal motif" that no one has ever used before, and repeat it all over a T-shirt or wrapping paper. You could be creative with your initial or design a simple motif that stands for your favorite subject or hobby.

Make a potato print of a favorite motif.

Use a potato print to stamp the motif. First cut a potato in half and press the cut side down on your journal drawing. The motif will transfer itself to the potato. Then carve around the motif with a knife to make it raised. Use fabric paint to pattern a T-shirt, and use poster paint or a stamp pad to make your own patterned giftwrap.

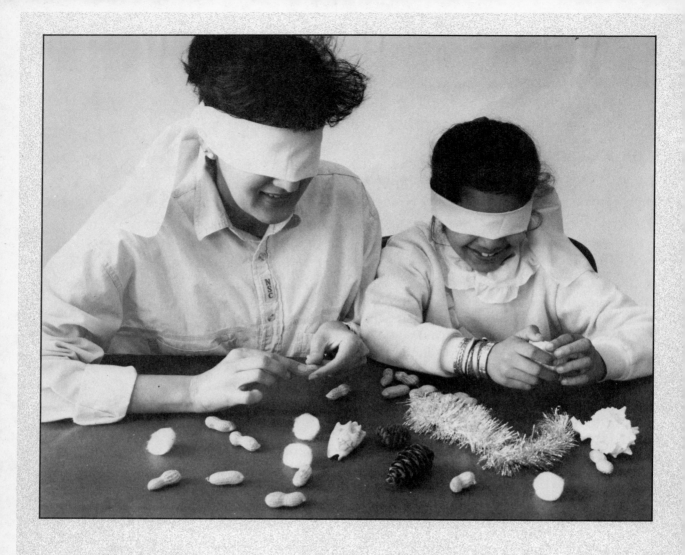

"When you get the feel of drawing, you learn to like it."

IZACH, age twelve

Texture

I n the first two chapters, you helped your child understand some very important elements of art. His drawing vocabulary is expanding daily as he becomes more and more conscious of what he is seeing and how he can use it.

In this chapter, you will introduce him to the world of *textures* around him.

Young children grasp the concept of texture very quickly, possibly because it is so closely linked to their initial impulses to touch and feel new objects. The attempt to capture the illusion of texture on a flat piece of paper, using only a variety of stroke sizes, widths, and pencil pressures, can create a wonderful sense of unity with the world. More than any other element of drawing, drawing texture will connect him to our physical world, from his body and senses of touch and sight to his mind and its search for art "equivalents."

Strangely, however, texture is one element that is rarely seen in children's drawings. Common textured subjects like concrete, lawns, or earth are seldom used. Where they do appear, they are suggested by few and inappropriate lines. Even in children's paintings, lawns and earth are usually suggested by areas of green or brown paint masses. Children will choose to draw smooth things with clean edges over furry things with rough edges, or they will draw rough things *as if* they are smooth.

Using a sketching style and many layers of overlapping lines, this boy has drawn a realistic portrait of a rabbit.

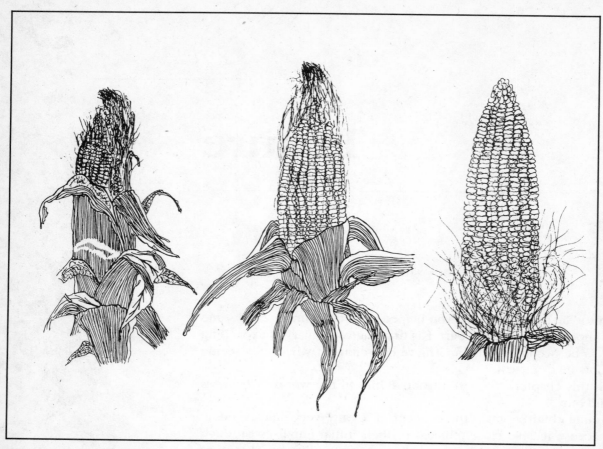

These beautiful drawings of corn by fifteen-year-old Sazid contrast the line patterns in the husks with the oval patterns of the kernels and the softer textures of cornsilk.

Perhaps one reason children avoid textured subjects is that they have not learned a vocabulary of marks that will enable them to represent texture with ease. The purpose of this chapter is to bridge that gap in their knowledge.

HELPING YOUR CHILD UNDERSTAND TEXTURE

The word *texture* refers to the way the surface of an object *feels*. When you run your hands over a surface, you may call the texture "smooth," "slippery," "rough," or "fuzzy." You might use words that seem to describe the temperature of the surface, like *clammy* or *dry*. Or you could compare the feel to other objects and use such words as *splintery, pebbled,* or *marbled*.

Using these words as a starting point, ask your child to first show you something *smooth* in the room. Have him run his hands over the surface and compare it to similar smooth surfaces. Ask him which

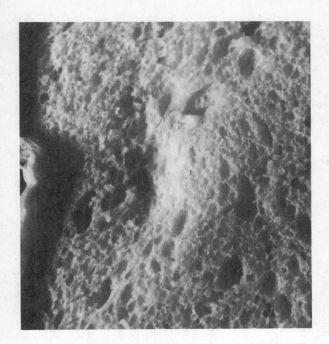 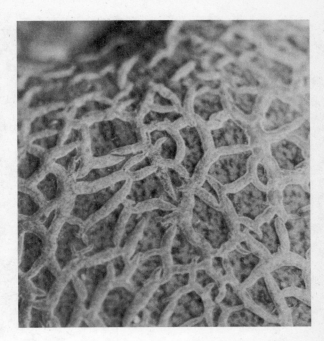

one is smoother, harder, colder, or shinier. He could feel them with his fingertips as well as with the palm, heel, or back of his hand. He could knock on them or lick them with his tongue. When he is looking at a rough surface, he could rub it with his sleeve to see if it is rough enough to snag the material.

Have your child "feel" many kinds of textures. Suggest taking a walk through the house, and help him use words to describe the different textures he finds. You will begin to notice that the kinds of words you are using to describe texture all have in common a description of the kind of *depth* you believe a surface has. Look at the textures in figures 21 and 22 with your child and ask him, "Which of these two textures looks the deepest or would feel the highest?" You can see that the areas of light and dark show the third dimension, which is depth or thickness. You can use words like *thick* or *deep* or *shallow* to describe texture.

In these examples, the bread texture is also "soft" while the cantaloupe texture is "rough."

LOOKING AT CHOICES

In this section, you and your child can first look at some drawings of textures that have "clues" to their origins, and then see how an artist used a series of patterned motifs to make his drawing look textured.

Figures 21 and 22:
Which of these two textures looks deeper?

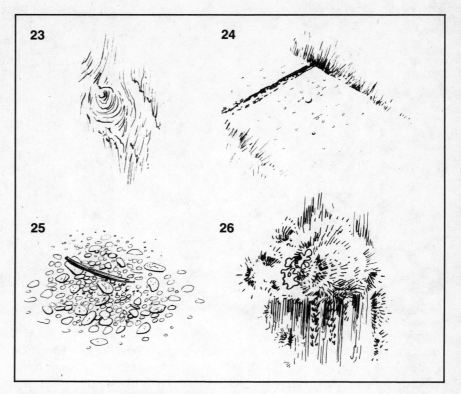

Seeing Textures in Nature

Unlike pattern, texture is usually uneven, and artists like to find the small flaws that will make a subject appear more natural when they draw it. Explain to your child that a flaw isn't necessarily a bad thing or a mistake; it is just something a little different or unusual from the rest of the texture. For example, artists look for the tiniest cracks in speckled rocks, the bug bites on shiny leaves, and wavy hairs left in a straight-bristled brush. They know that these details will give more realism to the overall texture because they provide some *contrast*.

Figures 23–26 show four close-up drawings of texture, as if the artist almost had his nose on his subject. Ask your child if he can identify each of these textures found in nature. He should respond with wood, cement sidewalk, gravel, and moss. Let him tell you what clues he had in each drawing. For example, he may have recognized the splinters in the wood, the crack in the sidewalk, the bit of wood in the gravel that helps show the size of the pebbles, or the tree bark showing through the moss. These details not only provide contrast, but they suggest *scale* too.

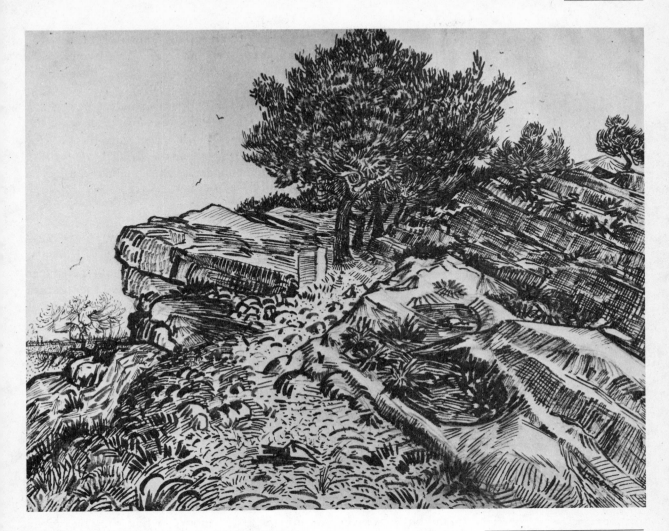

Looking at an Artist's Drawing

Drawings of texture in art run the gamut from the simplest pictures that use a few brief marks to "stand" for texture to fully realized equivalents that we think we can almost touch.

When your child looked at the drawing by Vincent van Gogh in figure 5, he saw that the artist used a reed pen and ink to make very simple lines. Figure 27 shows a different drawing by the same artist. *Rocks with Trees* is a detail of a drawing van Gogh made in a small French town 100 years ago. The simple repeated motifs make his drawing look almost patterned. You will be showing this drawing to your child and asking him to find the five motifs in figure 28.

Figure 27: *Rocks with Trees*, Vincent van Gogh, pen and ink.

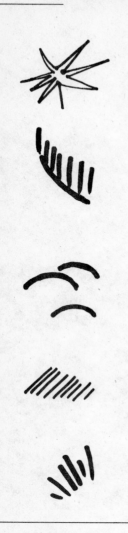

Figure 28: Can you find these five motifs in van Gogh's drawing?

Before you do this, talk about the motifs and ask him how the different groups of lines make him feel. For example, which feels smoothest? Which feels sharpest? Which ones could he imagine sitting on?

Then ask him what he thinks each of these motifs stands for. (The first one stands for plants, the second one for tree leaves, the third one for rocks, the fourth one for rock ledges, and the fifth for grass.) Now see if he can find each motif in the drawing. Help him see how they are repeated in different areas, with slight variations to show that they are *natural* and *irregular*.

USING TEXTURE IN DRAWINGS

When artists draw texture, they think about how smooth or deep it is, what kinds of marks or lines they should use, how wide the spaces are between the marks, and what direction or *grain* the texture takes. They also compare the scale or size of their texture marks to the *overall* size of their subject.

You can help your child learn to appreciate and plan how he will draw texture in the following exercises.

1. Recognizing and Naming Textures

Play a game guessing objects by how their textures feel. The purpose of the game is to familiarize yourselves with the objects and make decisions about how you will draw them based on the sense of touch before sight.

Without showing your child, collect things around the house with different textures, for example a nailbrush, tinsel, a cotton ball, a marble, or a piece of sandpaper. Hide them in a bag, then have your child feel and describe the contents of the bag.

Encourage him to use descriptive words. If your child says something feels "bumpy," ask him what he means by "bumpy." Raised? Rough? Full of holes? Covered with smooth bumps?

Take turns and have him collect a bag for you. Vary this exercise by having your child wear a blindfold and feel objects you have preselected and presented to him on a tray. This is especially good when working with more than one child.

2. Using Texture

These two exercises will give your child a unique point of view in drawing texture and a nice change of pace from line drawing.

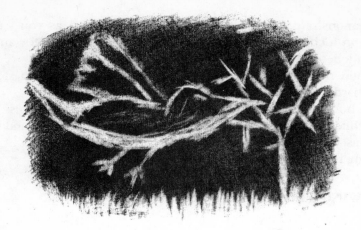

A young child's drawing of a bird, on paper covered in pencil lead using "erased" texture for the grass.

1. Erasing Texture on a Blackboard Cover a small blackboard with a chalk held flat on its side, and give your child a blackboard eraser to "draw" texture by erasing lines. Young children will enjoy the process of cleaning, chalking, and erasing the board as much as they enjoy drawing pictures with the eraser, so encourage simple abstract drawings such as "something soft," "something feathered," or "something grassy."

2. Erasing Texture on Paper Cover two pieces of paper with lead from a soft pencil, and polish them lightly with a tissue to even out the surface. Use your white vinyl erasers to "draw" texture by erasing it, as you did on the blackboard.

You will find you can make much finer detail, and may want to try drawing a "real" picture. Your child may like to draw one of the textured objects he examined earlier or the bird he patterned in chapter 2. You can explain to the older child that in this exercise he is now *erasing between* the texture marks he would normally have *drawn,* so he is really making the same drawing "in reverse." Show him how he is erasing the highlights of the raised areas and leaving out the dark areas that show the *depth* of the texture.

This is a very difficult concept to manage, and you will want to praise his efforts to understand. He will learn more about drawing light and dark in the next chapter.

TRYING DIFFERENT MEDIUMS

Many textures need a variety of pencil pressures to represent them. For a good exercise in control, practice different pencil pressures— from dark to light and light to dark.

Demonstrate for your child first. Press as hard as you can for about an inch, then gradually use less and less pressure for another three inches until the line fades out.

Then try the opposite. Press very lightly at first, then steadily press harder and harder until your line is as dark as can be.

In both cases, don't lift the pencil as you draw the lines. Show your child how the side of your hand remains on the paper and slides along as you draw. Have him alternate drawing both kinds of lines, drawing slowly and steadily.

DRAWING FROM LIFE

1. Drawing a Texture with Grain

For an exercise in learning to notice the *grain,* or direction, usually taken by a texture, choose a stuffed animal with long plush or fur.

Have your child start by drawing a very faint "ghost" outline of the shape with a pencil—head, body, legs, and so on. You may have to do this for your child. This will be his guide for the areas of texture.

Here's a tip: Instead of drawing a ghost outline he may wish to draw a heavy outline of the animal on a separate paper and use it as a guide underneath the one he uses for drawing the texture.

Before he begins to draw, have him look at each section of the body in turn and talk about the directions of the nap. Then encourage him to use short, overlapping lines to draw the texture of the plush in each area, following the grain.

Remind your child that where the plush goes *in,* he will make his strokes *darker.* Where the plush is *raised,* his strokes will be *lighter.*

Your child can make this exercise even more interesting by taping two or three pencils together and using them as if they were one pencil. The younger child will particularly like using three colored pencils together and may forget about drawing the animal. That's fine too!

2. Imitating Textures in Nature

Draw a series of two-inch boxes. Have your child fill them with different marks to imitate subjects like water, grass, rocks, sand, or bricks. He may wish to take a field trip to research his ideas outdoors.

You can then challenge him to draw more outrageous subjects like skin or popcorn or the surface of a balloon. Talk about the kinds

Can you see where the pencil pressure is hard or light in each sample?

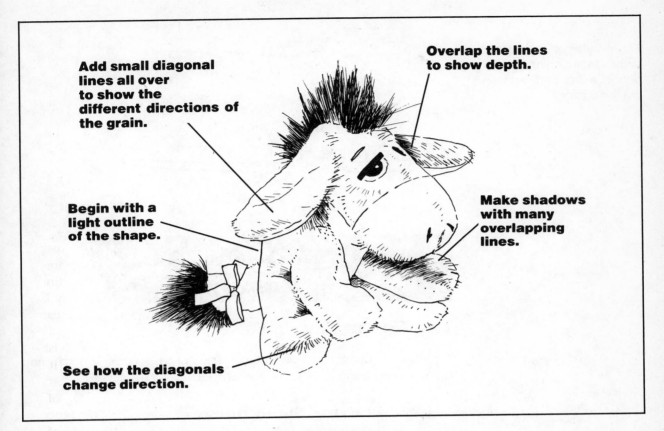

Add small diagonal lines all over to show the different directions of the grain.

Overlap the lines to show depth.

Begin with a light outline of the shape.

Make shadows with many overlapping lines.

See how the diagonals change direction.

of flaws each surface might have that give the viewer a clue as to what it is. Skin might have freckles, for example, or sand may have bits of shell in it.

Be sure to let him challenge you with his ideas for textures you can draw. If you're not sure how, suggest that you study the subjects first.

These drawings can be posted on your display board so family members can guess their origins.

ADDING ON

Drawing Line Textures

Have your child use a felt pen to draw natural subjects that use patterns of lines for their texture; for example, lawns or fields, long-haired animals, or driftwood. Talk about the directions of the lines—vertical, horizontal, or diagonal—and their lengths.

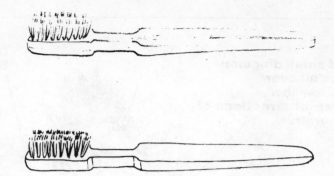

Three styles of drawing the same toothbrush: a soft pencil, a felt pen, and an erased drawing.

THE WORLD AROUND US

Try some of these ideas on outdoor trips or at parties. You will find the world around you is densely textured.

1. Experiencing "Smoothness"

Take your journals on a field trip to have a "smooth" day. Wear only smooth clothes, like lycra, spandex, raincoats, or bathing suits. Eat only smooth food, like hard-boiled eggs and grapes, and draw only smooth things.

Later, you could plan to have a "rough" day or a "soft" day.

2. Experiencing "Roughness"

Write your name with chalk on different surfaces in your yard, and see which surface uses up the most chalk. Talk about the reasons: the texture of the surface may be raised or splintered or very dry and crumbly.

3. Guessing Games for Outdoors

Play some blindfold games with texture outdoors. Blindfold your child and lead him to touch and guess different textures. Then feed

him foods with different textures and have him describe their feel while he is still blindfolded.

Take turns, or have a group of children participate as a birthday party game. You can blindfold them as a group.

Ideas for Touching

Spider webs

Water from a sprinkler set on low

Veins on the back side of leaves

Metal lawn furniture

Flower petals

Grass clippings

Ideas for Food

Watermelon

Chopped nuts

Pudding or yogurt

Shoestring licorice

Chopped lettuce or alfalfa sprouts

Crumbled crackers

Prepare a meal with different textured foods. How many textures can you find in this meal?

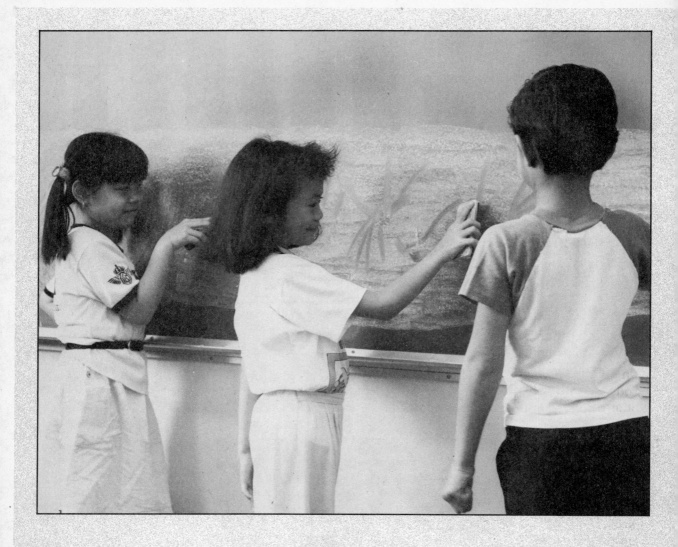

"I look at the shadows really hard and I concentrate so I don't make any mistakes."

MICAH, age seven

4

Light and Dark

*I*n addition to imagining and expressing with lines, you can now introduce your child to the concept of seeing *tones.* The study of light and dark, or tone, can help your child see the textures, shapes, and proportions of objects much more clearly and make it easier for her to draw many things. Children also love the increased illusionism that drawing in areas of contrasting tone can give to a picture. The concepts introduced in this chapter are further developed in the next two chapters on shading and shapes.

Children begin making interesting line drawings and patterns and coloring them with general areas of symbolic color long before they begin to draw with areas of light and dark. In fact, many adults have never perceived color in terms of light and dark *areas* and continue to make the simple line drawings of their childhood. In order to use tones in her drawings, your child must first understand that because we normally see in *color,* initially it is difficult to imagine color in different tones of light and dark gray as it is represented in drawings.

Even photographers who work with black-and-white film on a regular basis, and who think exclusively in terms of tones, have some difficulty mentally transferring their perceptions of the colors they are filming to the grays that they will become in the photographs. However, despite (or perhaps because of) the elusive nature of this kind of thinking, your child will find it a fascinating process.

Fourteen-year-old Cory has concentrated on drawing the dark shadow areas in this folded umbrella.

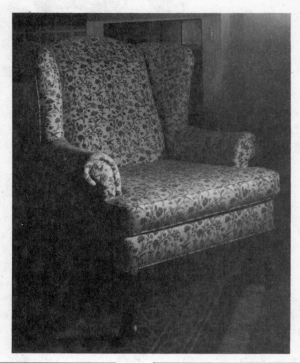

Figures 29 and 30 show
how the same chair is im-
agined first as a line draw-
ing and then as a tonal
drawing.

Figure 29

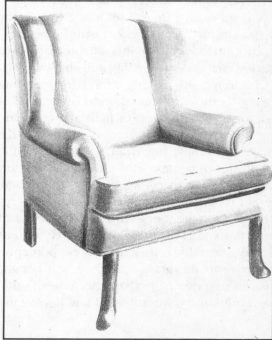

Figure 30

The purpose of this chapter is to help your child understand that she can draw light and dark areas as an equivalent for seeing colored objects. This is an unusual and stimulating approach that will quickly bring her closer to a more accurate portrayal of reality. In the same way that she learned to imagine lines, she can now learn to imagine tones. In the following exercises you can help her transfer from "color thinking" to "tonal thinking."

This photograph shows an orange skirt, black-and-white shoes, a yellow sweater, a green sock, a red T-shirt, pink mittens, and a royal blue hat with mauve pants underneath.

HELPING YOUR CHILD UNDERSTAND TONE

The word *tone* means the lightness and darkness of an object, and now is a good time to start using this word with your child. You could begin by asking her to show you something *light* in the room. This may be a piece of furniture, a white wall, or a light-colored toy or book.

Then ask her to show you some objects that she thinks are darker, and compare them to the lighter ones. Describe them using the word *tone*: "This book is blue and has a dark *tone*." Discuss the degrees of tones in different objects with her: "This yellow book has a lighter *tone* than this blue book."

With very young children you may need to provide some objects to begin. For example, present your child with a small yellow pillow and tell her that this is a light color. Show her something white and tell her that this is even *lighter*. Add a third object, perhaps red, and ask her which of the three is darkest. Continue to add objects to your lineup and see if she can put them in order from the lightest in tone to the darkest in tone. You could use, for example, a white towel, a yellow pillow, a red sweater, a blue book, a purple hat, and a black shoe.

With the older child, concentrate on objects that have a *similar* tone. For example, present her with a red hat and a green sweater and ask her which she thinks is darkest. Add a royal blue object and ask her which of the three is now the darkest or the lightest. She may say that they are all about the same tone and she would probably be right.

At this point you could ask your child to imagine that all the objects you are studying were gray rather than colored. Ask her, "If you took a black-and-white photograph of these objects, which one would be the darkest or lightest tone of gray in the photograph?" Provide her with the gray scale in figure 31. She can take this gray scale with her to various objects in the room and try to imagine which *degree* of gray on the scale each colored object would be.

Praise your child during all of these activities. You can assure her that she has learned an important new way of thinking in this session that will help her very much in her drawing.

LOOKING AT CHOICES

Tell your child that once an artist learns to imagine color in terms of tone, he can then make more choices about the style he will use.

The artist may decide to simply draw in the dark areas and leave the white areas blank, *without* drawing a line around the whole subject. This style would use solid tones of black and white. In order to do this he would have to imagine every tone of gray as being a choice between white or black and nothing in between. If the black areas were carefully drawn, they would clearly identify the subject. You can show your child the photograph of the clown in figure 32 and compare it to the black-and-white solid-tone drawing of the clown in figure 33. Ask her to find the gray areas in the photograph and notice how they are changed to either black or white areas in the illustration.

Figure 31: A five-tone gray scale.

Figure 32 A photograph of a clown.

Figure 33 See how the artist has copied some gray areas of the photograph with a black felt pen and left others white. This is a choice that he made.

Figure 34 Can you find all of these white areas in the photograph?

Figure 35: In this pencil drawing of a street light shining on two figures, a six-year-old has reversed the natural order of light and dark so the light looks more like a shower.

An unusual approach would be to draw with a white pencil on black paper. In this case, an artist would be drawing the white areas—including the highlights and all the light details—and *leaving out* the dark areas. Figure 34 shows a drawing of the clown photograph using a white pencil on black paper. You can help your child compare the light areas in the photograph to the areas of white pencil.

Explain to your child that this kind of drawing is difficult to imagine doing because the artist would be drawing the *reverse* of what he normally would draw. It is more usual to draw the dark areas or lines. You can help your child grasp the concept by asking her to imagine drawing a white cloud in a blue sky. Ask her which she would draw, the cloud or the sky, and which she would leave out. She will probably tell you she would draw the cloud because it is easier to understand drawing something that is nameable and *positive,* like a cloud, than it is to draw something obscure or *negative,* like a sky. In order to make the picture look realistic, however, your child would have to draw the sky by shading it lightly and leaving out the white cloud in the middle of that grayness. You could have her try drawing it both ways and compare the results.

This process is a good example of the kind of decisions that are made or not made by children when they draw, decisions that can lead to a lack of realism in their work. If you can continue to encourage your child to think about *tones* as well as *lines* when she draws, her drawings will soon become much more realistic.

Looking at an Artist's Drawing

Chuck Close is a contemporary artist who lives and works in New York. He is famous for his huge paintings, prints, and drawings of people. Close likes to show very close-up views of faces, and he usually uses his own friends for subjects. The unusual drawing in figure 36 was done by thumb-printing gray and black areas using his own thumb and an ink pad.

When he planned this drawing, Close analyzed his friend's face very carefully. He looked at the areas of the face that were the lightest, such as the forehead, nose, right-hand cheek, upper lip, and right-hand chin. If your child squints her eyes or stands across the room to look at this illustration, she will see how a light is shining on the right side of the face and casting the left-hand side of the face into darkness.

Close has seen where the shadows come down from the hair, along the eyebrow, down the side of the nose and the upper lip, and

down alongside of the mouth on the left-hand side. Have your child trace these shadows with her finger. Have her feel along the edge of the black shadow that defines the shape of the neck.

Show her how the pattern of thumbprints is very even, because the thumb has been held in the same direction for every print and spaced very symmetrically in a grid formation. The thumbprints also change *tone* to show the darkness of the shadows. When the ink was fresh on his finger, the fingerprints were black. As the ink dried, the fingerprints became grayer and he used them to make the lighter shades. Have your child find the areas of gray fingerprints.

Drawing of a turkey using fingerprints by Kelly, age five.

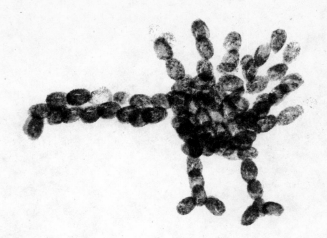

DRAWING FROM LIFE

As discussed earlier, the concept of light and dark is a difficult one, and your child should receive lots of praise and encouragement. For the younger child who is storing information about the world at large on a daily basis, even the preliminary exercises in comparing light and dark objects around the house will give her a good foundation for learning about relative shapes, sizes, and colors. For the older child who would normally draw *lines* around things as her standard approach to drawing, tonal drawings will expand her approaches.

In the next three exercises, your child will draw the areas she normally wouldn't draw.

1. An Invisible Drawing of Darkness

Your child will love making these drawings she can't "see" until they're finished.

Give your child some lemon juice, a brush, and some drawing paper. Have her choose two or three objects that will lie flat and that are light-colored, such as silver scissors, tweezers, or a plastic tape dispenser. She will place the scissors on the drawing paper and use the brush dipped in lemon juice to draw the background around the *outside* of the scissors. Then she can fill in the holes *inside* the handles or between the open blades because they are background, too. Rather than doing a drawing of the scissors, she is really making a drawing of the negative areas outside and behind the scissors as seen through the holes.

As she does this, talk to her about how she is making a drawing of something *light* by drawing the parts that are dark instead. You could tell her that the "holes" and "background spaces" even have a name. They are called *negative* spaces. She will learn more about using negative spaces in chapter 6.

After the drawings are dry, you can bake them in a 350-degree oven for two minutes. This will make the lemon juice areas turn dark and show off "ghost" silhouettes of the light-colored objects she has drawn. She might like to do another drawing and mail it to a friend to bake in his oven.

The older child can vary this exercise by drawing the backgrounds using bleach and a Q-Tip on black paper. The negative spaces will magically appear before her eyes.

2. Drawing Light

Provide your child with a white pencil crayon or a china marker and black paper for this exercise. She could also use chalk, although she will be able to make finer detail with a pencil crayon.

If you are working with a group of children, you can line them up along a blackboard, provide each with an object to draw, and have them all work at the same time on the blackboard as you move from one child to the other.

Have your child use her white pencil crayon to draw the light-colored objects onto *black paper* this time. She can use the objects from the last exercise, plus light-colored objects such as seashells, keys, or feathers. Suggest that she draw them life-size. She may want to begin by drawing a very faint ghost line around the silhouettes of the shapes in order to establish their sizes and shapes. She can then fill them in with solid areas of white, or, for objects that have texture or a pattern like a feather, she can use a series of repeated overlapping strokes.

Remind her to leave out any dark details as she works *and let the black paper stand for the dark areas.* For example, if a key has dark grooves or numbers imprinted on it, she will want to draw the key with the white pencil and leave the numbers and the grooves black.

In chapter 6, "Shapes," your child will examine areas of light and dark more closely and talk about them as positive or negative spaces. Meanwhile, you can encourage your child to talk about light and dark areas in patterns and textures as well as in subjects that are shaded.

An "invisible" lemon juice drawing baked in an oven.

A "magic" bleach drawing on black paper.

Joannie, age nine, has used a white pencil crayon to draw the highlights of the jewelry, key, and paper-clip on black paper.

ADDING ON

You can help your child reinforce these new ideas and techniques with the following drawing.

Drawing on Scratchboard

Even a preschooler will make beautiful drawings using this technique.

Visit an art supply store for a piece of scratchboard. This heavy card has a black coating that may be scratched or scraped with a needle, a dry pen nib, or a razor blade to make delicate white drawings.

Have your child plan a fantasy drawing of lines, textures, and patterns using outer space as her theme. She could visit the library as a resource for books about the planets, galaxies, and constellations.

THE WORLD AROUND US

1. Looking at Black-and-White Photographs

Buy a roll of black-and-white film and take pictures of familiar subjects such as your child's toys, your home, or pets.

Have the film developed and compare the black-and-white photographs to the original colored subjects. Discuss how dark or light the different colors are when they are reproduced in black-and-white tones.

Twelve-year-old Izach used a wide variety of expressive lines in his outer space scratchboard drawing.

2. Seeing in Black and White

Most animals do not see in color. Your dog sees the world like a black-and-white TV movie. Discuss the following:

How does your dog know what kind of food he is eating?

How does your dog recognize you from a distance?

How does your dog find his ball?

Watch a black-and-white TV movie and try to guess the colors.

"Drawing is really user-friendly! I like shading best."

KATHY, age ten

5

Shading

The most popular element of drawing, and the one children are most eager to learn, is that of *shading.* An appreciation of light and dark areas leads easily into the subject of shading.

Shading, also called *modeling,* gives the form three-dimensionality, or depth, and therefore greater illusionism. The illusionism is increased by the effects of light and shadow. A strong light on a subject will give it more pronounced shadow and will make it easier to draw.

Although older children sometimes use various shading methods in their drawings, they usually do it with difficulty. Most children have not had an opportunity to learn some simple techniques that would give them great pleasure. In the following exercises, you can help your child learn three useful techniques for shading.

HELPING YOUR CHILD UNDERSTAND SHADING

The word *shading* reminds us of the word *shadow,* and the word *modeling* reminds us of *shaping* clay or Play-Doh. These are two good ways to explain the meaning of shading in drawing. You are asking your child to think of the object he is drawing as something that has depth and that comes forward out of the paper so that he can imagine touching it and holding it.

This shaded pencil drawing is so "real" that we can almost touch it.

65

How many tones of gray can you find in these tennis balls? Compare them to the gray scale.

To use the techniques of shading appropriately, your child must think of himself as a sculptor as he draws. You can begin by taking him to a window of your house where strong light is coming in and talking about how shadows are made. The stronger the light, the more shadow is cast, and therefore the more three-dimensional objects appear. Find a piece of plain material in a light or medium color, take it to the window, and drape it over his arm. Show him where the light hits the folds of the fabric and casts shadows into the deepest creases. Help him examine the fabric to see where the light is strongest, where the shadows are deepest, and to see the areas of gray tones where the light changes to dark.

Now find a ball and bring the ball to the window. Show him how the light makes one side of the ball appear to be darker. Continue to bring different objects to the window such as cups, bowls, round toys, toy cars, even shoes. For each one, help him first use his finger to point to the places where the objects are light and then dark. Then ask him to pretend he is a *sculptor*. Have him close his eyes and feel the *depth* of the forms and feel how the forms turn *away* from him toward the window in a curve or corner. When he opens his eyes again, he can see where the shadows change to light as the form turns to the window.

LOOKING AT CHOICES

When a Line Drawing Isn't Enough

Tell your child that there are many simple forms with depth that do not look realistic in a line drawing. A line does not give enough information about the form, and he may need to use shading. Some of these may include vessels and circular shapes such as vases, cups, balls, or bowls; cylinders such as tree trunks, poles, legs, and arms; smooth water; and portraits. You can examine the two pairs of drawings with him in figures 37 and 38.

Show him first the line drawings and ask him if he can tell what they are. Then, before showing him the shaded drawings of the same subjects, ask him how the artist might have made his drawings clearer. When he compares the two, have him look at the places where the artist put in shading. Have him point to the areas the artist left light, the areas where he made the blackest shadows, and the areas that are gray. If your child is able to distinguish more than one shade of gray within these drawings, that is excellent. Show your child how the artist has shaded very *evenly* from light to dark so that there is no sudden jump between the two. The artist has really used several shades of gray in a row, and this chapter will teach your child the technique.

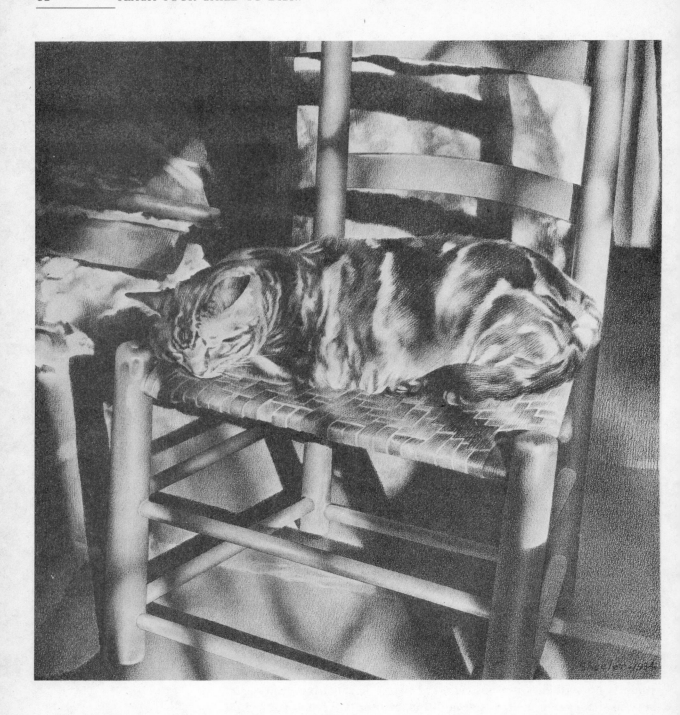

Looking at an Artist's Drawing

Charles Sheeler was an American artist who lived in the early 1900s. He loved to draw the effects of light and dark, especially hide-and-seek lighting effects made by sunlight coming through the window. This drawing of a cat, figure 39, was made with only a black conte crayon on textured white paper.

Help your child find the three following kinds of areas in Sheeler's illustration.

> Strong shadows cast by the chair onto the floor and background.
> Shadows cast by the cat onto the chair.
> Shadows cast by the chair onto the chair itself.

This is a beautiful example of a picture that captures a mood perfectly. The dreamy effect of the shadows merging and dissolving with the sunlight gives a timeless feeling to the drawing. Ask your child how this drawing makes him *feel.* Warm? Happy? Safe? Sleepy? Ask him what time of day he thinks it is, and what clues he has for his reasoning. Have him show you where the artist, in addition to shading, has used different textures for the cat and the chair seat, different patterns of light and dark, and strong lines.

USING SHADING IN DRAWINGS

At this point your child will be eager to try out different shading mediums. Children love to try these techniques for their own sake and will be excited by the "magic" of the following techniques. Later you will help him apply them to drawing subjects from life.

1. Shading with a Crayon

The success of this first technique depends a lot on the softness of the medium.

Find a piece of a dark crayon one or two inches long. If you have any oil pastels, colored chalks, charcoal, or conte crayons in your house, he may wish to use these instead of an ordinary wax crayon. Remove any paper wrappings from the crayons or pastels, and use ordinary white drawing paper for this exercise and the following ones.

Have your child hold the crayon on its side so that it is lying down on the paper and begin by rubbing the crayon back and forth across the paper to make marks. Have him rub it until it becomes

Figure 38: (Shaded drawing of a ball and tree trunk) Many forms need to be shaded.

Figure 39: *Feline Felicity,* Charles Sheeler, conte crayon.

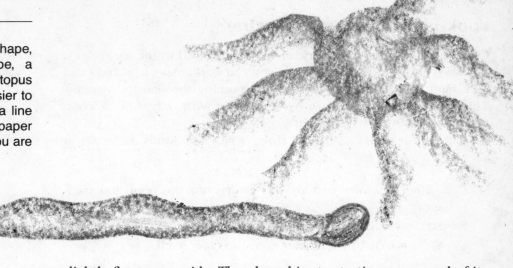

Examples of a leaf shape, a shaded ball shape, a snake, and an octopus using crayon. It is easier to shade both sides of a line if you turn your paper upside-down when you are halfway done.

slightly flat on one side. Then have him try to tip up one end of it a little so that he is pressing more heavily on the other end of it. He will find that the end on which he is pressing most heavily is making an edge, and the marks appear to shade out from that edge.

You could then encourage him to make shaded lines that are slightly curved or even like the letter *C.* If your child shades a curve and then turns his paper upside down and does the same thing again, the two C curves joined together will make a leaf. He could also make a ball shape with slightly rounder C curves.

Have your child also make some long, wavy shaded lines. If he turns his paper upside down and doubles them up with a second long shaded line, he can make a snake.

If he shades a ball and then adds short snakes to a ball, he can make an octopus.

2. Shading with Ink

Collect a number of water-soluble felt pens and ordinary writing pens. To test the pens, draw lines on a piece of white paper, wet your finger, and see which of the lines run. You want the ink to dissolve nicely when it is wet. Choose a pen for your child and one for yourself so you can do this with him.

Have your child use his pen to draw lines again for various shapes like leaves, balls, and tubes. He can then use a paint brush just slightly damp with water to blend the edges of the lines with a swiveling motion as shown in figure 40. He will quickly find through experimentation how much water he needs to make the lines run.

He can experiment with drawing a number of different subjects with the ink, then blend out his lines with water. He will find that organic subjects such as leaves, flower petals, branches, and rocks, and soft-textured objects such as stuffed animals, will work the best. Your child may enjoy drawing one of his stuffed animals with textural lines as he did in chapter 3, and then use the brush to shade out the lines. This will make his stuffed animal look very fluffy.

TRYING OUT DIFFERENT MEDIUMS

In this session, your child will learn the techniques for shading with a pencil. You can take your child through these explanations step by step after reading them for yourself.

1. Materials

It is possible to shade with an ordinary pencil, but if you can buy a very soft artist's pencil your child will be able to get a much wider variation of grays in his drawing. They will also be softer and more even.

Many artists use a white vinyl eraser, which they keep clean and sharpened with an X-Acto knife, for cleaning up shaded areas or removing smudges. In chapter 2 your child saw how this eraser could be used to remove the shading to create highlights in the texture.

2. Hand Position

Your child should hold his hand as shown in figure 40. The thumb and the forefinger hold the pencil; the other three fingers rest below it. Neither the wrist nor the arm move. As your child shades, his entire hand attached to the paper slides sideways across the drawing paper or up and down on the drawing paper.

3. Shading

Begin by having your child draw a short vertical line about a half-inch high. Have him go up and down on this line, pressing as heavily as he can.

Then, if he is right-handed, have him gradually shade to the right of this line, decreasing the pressure of his strokes as he moves. If he is left-handed, he will shade by moving to the left of the line. Have

Figure 40: This is a good hand position for shading with a pencil or a brush. The side of your hand stays on the paper and only the fingers swivel.

After you dip your brush in water, lightly wring out the bristles with your other thumb and forefinger so you don't have too much water on the brush.

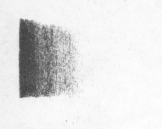

Figure 41: This shading decreases too quickly.

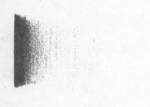

Figure 42: A correctly shaded line.

him decrease the pressure very gradually so that he does not finish with what appears to be a line with shading next to it (see figure 41).

If his strokes decrease in size so that the finished shape comes to a point, have him practice keeping all of his lines the same length. He will probably find this quite difficult. You can suggest that when the lines get very, very light, he should feel like he is barely making contact with the paper—almost as if he is drawing above the surface of the paper.

When he has drawn a number of shaded edges similar to those in figure 42, have him draw a slightly curved C as in figure 43 and also shade it inward. If he then rotates the paper and repeats this shaded C four times, allowing each section to come to a point like a triangle, he will be able to draw a shaded ball in four sections as shown in figure 44. He can add extra shading on top of the places where the four sections meet to blend them together more smoothly.

Allow your child at least a full session to experiment with these various shading techniques. As well as trying them with his drawing pencil, he may wish to try them with a colored pencil crayon or with a wax crayon and compare the different "feels" of the mediums.

DRAWING FROM LIFE

In the following exercises your child will apply these techniques to drawing simple objects from life, using a strong light to cast shadows on them and to make it easier for him to see their shadows.

Several kinds of lighting sources can be used. The best would be natural light coming through a window. The next best would be from a small lamp or steady light two or three feet away from the object. An overhead light in the room will probably not be sufficient. The older child may enjoy working by candlelight, which will give a beautiful soft and diffuse light to his subjects.

1. Setting Up

Begin by setting up his work space and the light, including drawing pencils and paper. Have your child help you find a small round ball about the size of a tennis ball; a differently shaped ball, such as a small toy football; and a cylinder shape, such as a fat pencil, an empty toilet paper roll, or a baseball bat. Encourage him to start with the smallest and work his way up in size.

He will need some type of vessel, like a coffee mug, a child's cup, or a baby bottle, and some kind of small rounded object like a toy Volkswagen car or a rounded conch shell. These objects will give

him a good variety of forms. He need not draw all of them, simply the ones that he is most interested in drawing.

2. Choosing a View

Have him choose his first subject and place it on a piece of white drawing paper in front of him. Help your child choose the best *view* of the object he is going to draw, and help him choose the best *lighting effect* on it.

For example, a direct backlight on a ball would make it look very flat, so this would not be the best choice. A straight-on sideways light may also make the shadows too half-and-half. Have him try a light that comes slightly from an angle, either from the front or from behind. Also show him the shadows that are cast on the drawing paper *under* the subject, and arrange the light until those shadows have a pleasing shape.

3. Analyzing the Tones

Now help your child analyze the form that he is about to draw before he begins actually drawing it. Have him look at the shading within the object itself and on the different parts of the object.

If he is going to draw a cup, for example, have him look at the shading within the opening of the cup, on the front surface of the cup, and on the handle of the cup. If he narrows and squints his eyes when he is looking at the cup it may make it easier for him to pick out these areas of light and dark. Have him also look at the shadow that the subject is casting onto the drawing paper, and notice that it is darker right under the object and then fades out so that the edges of the cast shadow are very soft.

Figures 43 and 44: An example of a C shape and a ball shape shaded by pencil.

Shine a strong light on a rough or spiky object and look at the place where the light *changes* to dark. You will find that this is where the texture is most obvious.

With an older child, you can show him where there is *backlight* on his object. Backlight often causes a narrow edge of lightness next to shading. It gives forms a strong feeling of roundness, and therefore it is ideal to include it whenever he is drawing round objects.

4. Drawing the Tones

When your child begins to draw he will need two more pieces of paper. Have him start with a felt pen outline drawing of the subject on one sheet, and place it under the second one so that it shows through. This outline will be his guide for his shading, and he won't have to worry about drawing the shape as he concentrates on seeing the tones and shading them with a pencil on the top paper.

Have him begin by shading the *blackest* areas first. Then have him go back and shade the gray areas using the techniques from the previous section. When he has finished shading each subject, he can use a sharpened eraser to "remove" the spikes or rough areas, to touch up any highlights, or add strokes for texture.

ADDING ON

Drawing a Magic Garden

Your child could draw an imaginary landscape or garden scene with lots of pattern and texture. He will find plenty of good reference material in the botany or gardening sections of your library, or he could "collect" small sketches outdoors in his journal first.

Encourage him to draw his largest subjects first, using simple lines. He can then add textures, patterns, and smaller "filler" plants between the large ones. Have him draw them with a water-soluble pen, then use a brush and water to blend the edges out. *Remind him to leave some areas on the paper dry for his highlights.*

THE WORLD AROUND US

Your child will be able to find shading everywhere in his world, and can now imagine how he might draw it. Here are some suggestions for extending his imagination.

1. Looking for Shading

Look for shading and shadows everywhere you go.

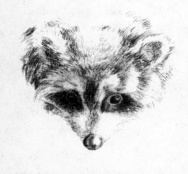

This raccoon drawing by Ross, age 16, is both textured and shaded.

Walk around your backyard and find *backlight* on tree trunks and branches, rocks, flowers, fence posts, and lawn furniture. See how many examples you can find.

Look in the sports section of your newspaper for photographs of people in action. Look at shadows on the figures and at dark and light areas in out-of-focus backgrounds.

2. Dining by Candlelight

Have dinner by candlelight in a dark room.

Eat foods with interesting textures, such as casseroles and mixed vegetables. Guess the foods by their light and dark shapes and textures. Look at shadows on the table and on faces. Think about how you would draw them.

A fantasy garden scene by Micah, age seven, who used a water-soluble pen and a brush. "The sun is coming this way [from the right] so I put the shadows here [on the left]."

"Try to make a shape, and look at the edges and what's inside it."

<div align="right">Iqbal, age eight</div>

6

Shapes

Your child will find it easier to understand the concepts of shape now that she can imagine lines around shapes as well as see the tones of shapes. In the two sections of this chapter, you will help her see both the *underlying shapes* of objects (their positive shapes) and the shapes made by the air around them (their negative shapes). Each section teaches a different way of seeing exactly the same thing.

I. POSITIVE SHAPES

Your child has a natural ability to reduce three-dimensional forms to shapes, although she does not use them in a realistic way. When children first begin to draw shapes between the ages of three and five, they reduce all realistic things to such geometric shapes as circles, squares, triangles, and rectangles. Even if the subjects do not really have those shapes, they are universally used as solutions for the closest equivalents.

As they grow older, children expand their vocabulary of basic shapes by combining them and adding new symbols. However, as they strive to communicate more clearly, they often express dissatisfaction with the lack of "realism" in their drawings. The "closest equivalents," which were once so handy for communicating what something *means,* are no longer enough to express what something

By drawing the negative shapes she saw around the chair and between the rungs of the back, this mother also made a positive drawing of the chair itself.

Common symbols found in young children's drawings that get in the way of drawing realistically.

These eight-year-olds have learned to see more realistic forms. Compare them to the early symbols.

looks like. Many children cease drawing altogether at this stage and later on, as adults, apologize for their simple symbols.

When children begin to "need more" in their drawings, they are becoming aware of their inadequate symbolic vocabulary. You can easily help your child pass this hurdle by showing her how to temporarily reduce real forms to basic positive shapes, *for only the time it takes to perceive them more easily in order to draw them.*

HELPING YOUR CHILD UNDERSTAND POSITIVE SHAPES

Looking at Geometric Shapes

Beneath the surfaces of pattern, texture, light, dark, and shading lies the element of shape. A shape is two-dimensional, which means it has only height and width, such as a square, a triangle, a rectangle, or a circle. These shapes are also called *positive* shapes, because they are easy to name or describe.

If your child is very young, you could draw on her back or on the back of her hand simple positive shapes like circles, squares, triangles, rectangles, and ovals. Help her use a vocabulary of easy words to describe them, such as *tall* or *high rectangles, narrow* or *thin rectangles, long* or *short triangles,* or *wide ovals.*

She can examine the photograph in figure 45 and find some simple geometric shapes in it.

Figure 45:

You can point out where some of these shapes are repeated to make patterns, and help her find and count the different patterns. She should be able to find the ovals of eggs by herself quite easily though you might help her see the sandwich triangles. Ask her if she can find the pattern of squares in the cloth, and show her the rectangular shapes of the lunchbox. Talk about other subjects that might have these shapes as their form, and then take her on a hunt for these shapes in your home environment.

Ask her if she can find any of these shapes in the room. You might point out a square sofa cushion or a rectangular television screen. If you have area rugs, or paintings on your walls, talk about the different shapes and sizes of the rectangles. For circular shapes, point out all the various door knobs and dials you can see. You can also have your child select a handful of small toys, such as cars, and have her feel the different shapes within each toy, like the circular wheels, rectangular bodies or cabs, and rectangular or square windows. She could go on a hunt for triangles, which she will most likely find in cone shapes like birthday party hats, ice-cream cones, and stacking toys.

Reinforce these ideas after your session by encouraging her to see geometric shapes in the world around her. Once you start looking, it's hard to stop!

Can you find each of these shapes in the photograph of the lunchbox?

An olive
An egg yolk
A square of the tablecloth pattern
An orange section
A sandwich triangle
The surface of the milk
A cheese star

Looking at Letter Shapes

In your next session, you can go through the letters of the alphabet with your child, and talk about the shapes made by the different letters. If you have a set of plastic alphabet letters or a set printed on a poster, use these as a reference. Show her how the letter *A* is like a triangle with a horizontal line halfway up it. *B* looks like two circles with a vertical line on its left-hand side. *C* looks like a half circle, and *D* looks like the other half of the circle, but with a vertical line on its left. An *E* is like two squares stacked on top of each other with one side open, and so on. Take your time and analyze each letter with her, and have her trace around the shapes with her finger so she can feel them.

She can study the photographs in figures 46–49, and look for alphabet letter shapes hidden in the objects. (She should be able to find the hidden letters *A, H, V,* and *X.*)

Complete this session by having her look for alphabet letter shapes hidden in things around your house. She may want to pick letters of the alphabet—either handwritten or plastic—from a hat, and go on a search for an object with a shape that matches each letter. This would be an especially good game if you were working with a group of children.

Remind her that the letter shapes may be upside down or sideways. You could keep a list of the 26 letters of the alphabet, and as she finds a subject to match each one, write it next to the letter.

LOOKING AT CHOICES

Comparing Symbolic and Realistic Drawings

You can help your child understand the differences between a symbolic drawing and a realistic drawing by showing her figures 50 and 51 of bees. Have her first draw her own picture of a bee and include the features of a bee that she thinks are necessary: stripes, wings, eyes, stinger, and so on. She can then compare her drawing to the child's drawing of a bee in figure 50 and to the artist's drawing in figure 51.

You could ask her, "What else has the artist included? Does the bee have a fuzzy body? How many legs does it have? Where is the stinger?" You can also point out any differences in the *shapes* found in the artist's drawing: the triangular wings, the rectangular bodies, and the circular heads (see figure 52). She can look at the *patterns* of

Figures 46—49: Can you find the lettershapes in each photograph?

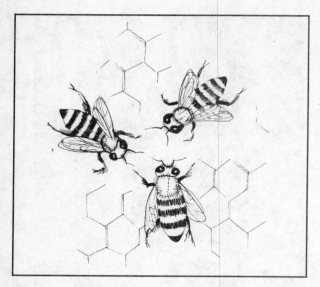

Figure 50: Child's drawing of a bee.

Figure 51: Artist's drawing of a bee.

Figure 52: Shapes found in a bee's body. Can you match them to the artist's drawing?

short lines used for the fuzzy *texture* of the bodies, and also the *patterns* of stripes. Be sure to praise her for all the features that her drawings have in common with the artist's.

You can also explain that when your child wants to draw realistically, she will often need to find a reference for her subjects because even an adult artist couldn't possibly remember all the details of everything in the world, from all points of view and in all kinds of lighting. This is why artists who draw realistically like to "draw from life" or use photographs, reference books, or picture files at the library.

Looking at an Artist's Drawing

Every artist has his or her own special interest. Remind your child how Vincent van Gogh used short lines to stand for many different things and how David Hockney loves patterns. (You will be showing her another example of Hockney's work in chapter 9, "Movement".) Charles Sheeler and Chuck Close both like to shade with light and dark to make pictures that are so realistic they often look like photographs.

Paul Cézanne was a famous French artist who was very interested in forms and shapes. Figure 53, *Fruit Dish and Apples,* shows an arrangement of fruit, china, and draped cloths that Cézanne painted. Study it with your child and have her trace with her finger all the different round shapes in the painting. Show her where there are

smaller shapes within larger ones, such as the round apple shapes in the round bowl. She might like to do a diagram of the shapes that she finds. Or she could visit the library for a book about Cézanne's work to see the many beautiful variations of this composition which he painted.

Figure 53. *Fruit Dish and Apples,* Paul Cézanne.

USING POSITIVE SHAPES IN DRAWINGS

Combining Shapes

In this exercise, you can help your child recognize, name, and combine simple shapes to make her own pictures. You can use white, black, or colored papers to make the shapes. The purpose of the game is to help your child focus on the "feel" and appearance of shapes.

Snip the papers into dozens of pieces of different shapes: circles, squares, triangles, sticks, ovals, zigzags, moons, curved shapes,

pointed shapes, and so on. Be sure to keep the scraps *between* the shapes as well, as she will find them useful.

Take turns challenging each other to make pictures by combining these shapes, using subjects—like transportation, animals, buildings and street scenes, or clothing—found in reference books. Study the *underlying shapes* of the parts in the photographs or illustrations and then find shapes of paper to match: talk about finding "equivalents." For example, your child may ask you to copy a train, and you can combine circles for wheels, rectangles for the cars, and so on. A butterfly shape could be made with two triangles and a stick shape. Discuss the differences between your combinations of paper shapes and the real shapes in the photographs.

Drawing from Life

Your child is now ready to find and draw real objects that have two-dimensional shapes hidden in their three-dimensional forms. The perception and discussion of these underlying shapes first will aid her accuracy in both seeing them and in drawing them.

1. Drawing Forms with Geometric Shapes

You and your child can draw three things in your house for each of the following five shapes.

Find subjects for each one in turn: a circle, a square, a triangle, a long skinny rectangle, and a sphere or oval. Analyze each group of subjects with your child, beginning with circular shapes. Have her notice any markings or details on the surfaces and whether the edges are perfectly smooth or slightly contoured. For example, she may find a brass doorknob that is smooth with no markings; a glass doorknob that is cut in bevels; and a television dial that has rows of circles within circles and a diagonal line for turning. After she has drawn three different circular shapes, she can find three subjects for each of the other shapes. When you have both finished, you can compare your choices.

2. Guessing Shapes

In your next session, you can look at forms that *combine* different shapes.

Raid the kitchen drawers and the work room for unusual tools and hardware with odd shapes. Hide them in a bag. Have your child do the same.

Eight-year-old Ian found geometric shapes in this totem pole.

These precise contour silhouettes were drawn by thirteen-year-old students. Can you identify each one?

Start by hiding one of your own objects in your lap and describing its shape to her. You could say, for example, "It is round and it has holes." If she doesn't guess, continue your description: "It is symmetrical, it has depth and a T shape at the top." Continue to describe the shape of the object until your child guesses. Then have her try to describe the shape of one of her objects to you.

Do not describe the use or the purpose of the tool. Try to describe only its *physical* properties, such as its length, width, depth, proportions, symmetry, and protruding shapes. These are the properties that an artist analyzes first.

3. Drawing Silhouettes

After you have each described and guessed all of the objects in your bags, you can make simple silhouette drawings of the shapes using a pencil on white paper.

Encourage your child to begin with *a very light outline of the underlying shapes.* A hammer, for example, has a long rectangular handle topped with a sideways rectangle that has a head on one side and a curved point on the other. Help her check her proportions, and then redraw her lines darker. As she retraces around the edges, show her any small nuances of curves, indentations, notches, or grooves for her lines. Remind her how the little flaws in texture help make it look "real."

No. 89, Monique Fouquet, charcoal and graphite. How many shapes, textures, and patterns can you find in this charcoal drawing? You could begin by finding all the *cone* shapes.

When you are both finished, you can check your accuracy. Take turns holding an object in one hand, holding a flashlight or lamp in the other, and shining it on the object so that a silhouette shape is made on the wall. Tape a piece of paper on the wall and trace new drawings of the silhouettes to compare with yours, or simply hold your drawings next to the silhouettes and talk about any differences in your perceptions.

ADDING ON

Drawing Fantasy Shapes

At this point your child may be able to produce some very beautiful abstract drawings of imaginary shapes using added textures, patterns, and shading.

Ask her to imagine some fantasy shapes and backgrounds, such as rocks covered with fur traveling through space or over a pattern of light and dark stars; cubes of splintered wood lying on folds of fabric; or a pattern of stripes shaded like tubes.

Talk about contrasting different kinds of shapes to each other; playing off smooth surfaces against rough ones and light areas against

dark areas; and shading one subject so it appears to blend into another one. Some additional subjects for textures might be baskets, sand, or grass. For patterns, she could include checkers, polka dots, or paisleys. For shapes, she could also use bananas, cones, or tennis balls.

II. Negative Shapes

In the previous sessions your child has concentrated on seeing positive or nameable shapes such as triangles or alphabet letters inside objects, and then using this perception to help her draw them.

Another approach that will greatly help your child's accuracy is the ability to understand *negative* shapes. Negative shapes are much harder to talk about because they can't always be named or compared to other shapes. Seeing negative shapes also means seeing the outside of subjects, which she wouldn't normally look at.

In spite of this, children frequently understand the concept of negative space quite readily once it is pointed out to them. You will know immediately if she is old enough to be introduced to this concept if she understands the vase/profile illustration in figure 54.

Helping Your Child Understand Negative Shapes

Look at the following example, and tell your child that you are going to show her an interesting trick to help her draw.

Figure 54 is a classic example of what appears to be a vase. However, if your child looks at the air that is pushing into the vase from the outside, she will see two bears looking inward at each other.

Explain that this drawing gives her a chance to see *two things at the same time,* in one drawing.

Now you can take her to look at the armchair that you used in your discussion of line in chapter 1. Remind her how she *imagined* lines around this chair. This time, ask her to imagine a line around the background *behind* the chair. That is, ask her to show you where the background stops and see if she can understand that *the background stops along the edges of the chair.* You can use your arms and hands to physically demonstrate the air pushing in to the chair. Show her how the air suddenly stops where it meets the chair.

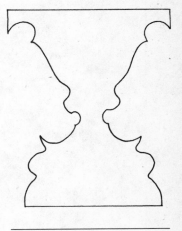

Figure 54: Can you see the happy bears?

Figure 55a: This figure shows how the background ends where it meets the chair. The chair is like an empty space or hole in the world.

Figure 55b: Every line that she draws means two things. This line stands for both the background and the chair.

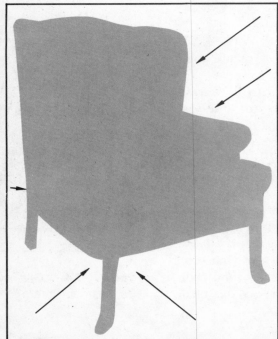

Figure 55a

Figure 55b

USING NEGATIVE SHAPES IN DRAWINGS

When a subject has a more difficult silhouette, it often helps to be able to see how the air around it is pushing into the object from the outside. For example, plants and chairs are typical subjects that are difficult to draw unless you also look at the spaces around and between their leaves, or around and between a chair's legs and backs. In the following exercises, your child will concentrate on seeing these shapes that are made by backgrounds or negative spaces.

1. Looking at Negative Shapes Made by Pennies

Draw a one-and-a-half-inch square for your child. Have her arrange three pennies inside the square or slightly overlapping it. Explain that she is only going to draw the shapes *between the pennies* and the shapes *between the pennies and the edges of the square.* You can point these out to her and even have her count them.

Figure 56: Draw the shapes *around* the pennies.

Beginning at each corner and working in, have her shade the negative shapes inside the square *around* and *between* the pennies. Rather than drawing lines around the pennies, her shading will simply stop at their edges (see figure 56).

Remind her that this exercise is similar to the way she drew the dark spaces around the light-colored scissors with a brush and lemon juice in chapter 4.

Have her move the pennies off the square when she is finished and look at the shaded shapes. Ask her to describe the shapes for you: long, thin, triangular, like a letter *Y,* and so forth. Tell her that by drawing the background she has also "magically" made penny shapes that she can see in the white areas.

2. Looking at Shapes Made by Loops

For this exercise, provide her with loops of string arranged inside a four-inch square. Your child will shade *inside* the loops, as well as on either side of the string (see figure 57).

This exercise will make a good point of reference when she is drawing subjects from life that have spaces or "holes" between them, such as branches of trees. As well as seeing the different directions taken by the lines of the branches, she will be able to see the negative shapes of the sky between them. She may like to extend this exercise by taking her journal with her on a walk or to a window to draw the negative spaces between bare tree branches.

Figure 57: A negative-space drawing between the loops of string.

Figure 58: Photograph of leaves on a plant.

Figure 59: Help your child find each of these negative shapes between the leaves.

DRAWING FROM LIFE

In the next two exercises, figures 58 and 59 will show your child two examples of where she might see negative shapes in your home.

1. Finding Negative Shapes in a Plant

Show your child figure 58 and ask her to use her finger to trace around the negative shapes between the leaves and stems of the plant.

She can then place a piece of tracing paper over the photograph and, with a fine-tip black felt pen, solidly fill in all of the different negative shapes, including the four in figure 59. She will have a white silhouette of the plant when she is finished. Talk about the shapes made by the solid background spaces she has drawn.

2. Finding and Drawing Negative Shapes in a Chair

Your child can use the same techniques for looking at a photograph of a chair, then look for negative spaces in a *real* chair with you.

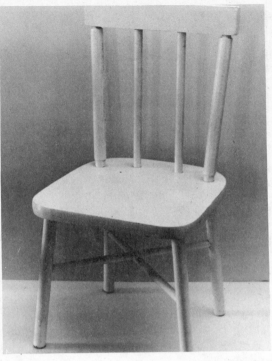

Figure 60: Trace the negative shapes around this chair with your finger.

Show your child figure 60, and ask her to first trace with her finger around the negative shapes between the chair legs and between the chair and the edge of the photograph.

How many negative shapes can she find? Have her trace them with a felt pen and tracing paper as she did in the last exercise. Discuss the shapes of these areas when she is finished: some are rectangles and some are triangles.

Then sit with her in front of a real chair similar to the one in the photograph. With one eye closed, have her trace around the negative shapes with her finger or with a pencil *in the air*. Turn the chair to different points of view and talk about how these shapes change when the chair is moved.

She may now like to try a drawing from life of one of her views. She can start by drawing the edges of the background where it meets the outside of the chair. *She will have a white silhouette of the chair,* similar to figure 55. Next she will add the interior negative spaces or "holes," which she will see between the legs or the rungs of the back. She can shade each negative space solidly when she is finished or leave the chairs as line drawings. This is a very advanced technique, and you will want to praise her for learning a really difficult concept and for her growth in concentration skills.

A sixteen-year-old has drawn both a chair and its shadow shapes.

Can you identify the subjects of this negative-space drawing by a thirteen-year-old student?

3. Ideas for More Drawings of Negative Shapes

Artists like to draw all kinds of subjects with "holes" or spaces in them because these shapes make their drawings more interesting. Seeing both negative and positive shapes is also rather like fitting together a solid puzzle of the world in which there are no gaps. She may enjoy trying some of these suggestions for more subjects that have lots of spaces between them.

a. Flowers arranged in a vase.

b. A Meccano or Tinkertoy construction.

c. A fern.

d. A rocking chair.

e. A tricycle.

ADDING ON

Drawing a Portrait

In this drawing, your child can combine her new understanding of both positive and negative shapes with one or more techniques for drawing light and dark.

Pose for your child with a strong lamp shining on one side of your face so that the other side is in dark shadow. Have her use lemon juice and a brush to first draw the large dark shapes on the shadow side. Then ask her if she can see the smaller dark shapes on the shadow side.

A lemon juice portrait of dark shapes and textures.

Ask her if she can now see the small dark shapes on the *light* side, such as shapes across the bridge of your nose, under your eyes, nose, and mouth, under your cheekbone and chin, and next to your ear. She can first describe these shapes and then "draw" the areas in with lemon juice.

Bake the dry drawing in a 350-degree oven for two minutes to make the lemon juice turn dark in the shadow areas. Your child may then like to try this exercise again using a black crayon to draw all the dark areas.

THE WORLD AROUND US

Children love to guess mystery shapes and to imagine that they "see" things in natural forms.

1. Drawing with Light

Use a flashlight on a dark wall to "draw" a circle, a zigzag, a wavy line, letters of the alphabet, or any other simple shapes such as fruit. Have family members try to guess the shapes that you have drawn.

At Halloween or the Fourth of July, use a sparkler outdoors to "draw" shapes in the air. Your eyes will see a brief afterimage of the path of light.

2. Seeing Shapes in Nature

Look for hidden images everywhere: in clouds, linoleum, plaster walls, rocks, and mountain ranges.

Talk about *equivalent* shapes. For example, a rock may have a triangular outcropping that can be seen as an equivalent to the shape of a nose in a profile. Or the contours of a section of plaster may resemble an animal.

3. Looking for Negative Shapes in Shadows Outdoors

Go for a walk on a sunny day and look for the shadows of fences and gates on the ground.

Look at the negative shapes of sunlight coming through the slats of the silhouettes. See dappled sunlight cast through the leaves of trees to make patterns of light and dark on grass, or look for shadows of street wires cast on the ground with negative spaces between them.

Can you see the shape of a pig's head in this linoleum?

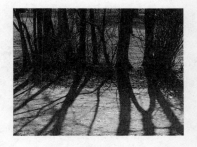

The negative shapes of sunlight come through this group of trees.

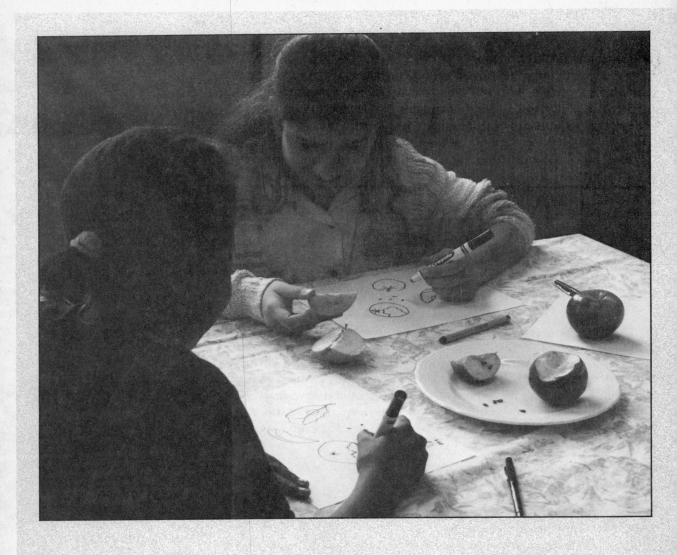

"Always think about what you draw before you start."

ALBERT, age six

Proportion

*P*roportion refers to the size or shape of one area or subject compared to another. You will use words like *larger, smaller, longer, shorter, wider,* or *narrower* to compare proportions of different areas to each other.

Although the concept of proportion is quite abstract, children are very interested in it and can become skilled at applying it. For one thing, they are used to seeing changing proportion every day in comic books, in animation, and in computer graphics. Cartoon characters magically grow larger or smaller as fits their needs; they change shape completely; or the characters either become dwarfed by their surroundings or larger than life like giants and super heroes.

In their drawings, children give arbitrary importance to different subjects in their drawings based on their emotions and needs. It is relatively common to see a child draw himself larger than his parents, for example, or a mother drawn much larger than anyone else in the family, depending on the feelings of the child.

However, to realistically draw subjects from their homes, school, hobbies, friends, and lives in general, children must shift gears to the actual. They must learn to do two things: to see and compare the actual sizes and shapes of different subjects *to each other,* and to compare parts of one subject to other parts of the *same subject.* In both cases, your child will be estimating sizes, shapes, volumes, and distance.

Seven-year-old Patricia has drawn herself as large as and in more detail than her parents.

A felt-pen drawing comparing two different saws by Jim, age 12. Ask your child to compare the proportions: which is *longer, shorter,* or *wider*?

Artists compare relative sizes with their eyes only, but often use one part of the whole as a standard or *unit* to estimate the size of the whole. Your child already uses the concept of units unconsciously, and you can help him become more aware of this process.

HELPING YOUR CHILD UNDERSTAND PROPORTION

In this session, you can help your child understand the concept of proportion by looking at different subjects for their relative sizes and volumes. Begin by having your child compare subjects of similar sizes, such as two different pillows, and ask him which is larger or smaller. You could give him a stack of books and ask him to sort them from small to large or from thin to thick. If you have a jar of pencils and crayons nearby, ask him to sort them from short to long; he could also separate the thin pencils and crayons from the thick pencils and crayons. You might ask your older child to show you all the different ways that one jar of pencils could be sorted.

Encourage him to use words like *bigger, larger, smaller, longer, shorter, wider, narrower, thinner,* and *thicker.* Tell him that you are looking at the *proportions* of things, which means the *size of one thing next to another.* When you feel that he understands how to compare different things laid side by side, gradually move them away from him to an arm's distance so he will have to judge their relative

Which bottle has the longest neck? Which one has the widest neck?

sizes with his eyes. At this point you could hold up different shapes and sizes of wine glasses, for example, and ask him to guess by *looking* at them which ones are longer, larger, or taller.

Explain that evaluating proportion is a *visual* task. Tell him that artists judge the sizes of things—even in the distance—with their eyes and that with practice they can become very good at estimating correctly. You can continue with the following ideas for evaluating *volume.*

Select two or three jars from small to large, and give him a bag of marbles. If you don't have any marbles, you could use Cheerios, jelly beans, or pennies. He can start by dumping some marbles out in a pile on the floor or holding them in his hands and feeling their weight and size. Now ask him to imagine which jar the marbles would fill: the small one, the medium one, or the large one. He is comparing the proportions of the marbles as a group or as a *volume* to the volumes available in the three jars. After he has imagined which jar they would fill, he can fill it and see if he is right. You may want to repeat this game two or three times using varying amounts of marbles and different containers.

Figure 61: Which tree is taller?

Figure 62: Which cylinder is the largest?

Figure 63: Which rectangle is the widest?

Have him next evaluate the volume of a liquid. This is a good game to play in the bathtub. Provide him with a set of measuring spoons and a small empty glass, plus a source of water if he is not in the bathtub. Ask him to choose one of the measuring spoons and feel its potential volume with his finger. Ask him to first imagine how many spoons of water it would take to fill the glass. He could then fill the glass with spoonfuls of water to check his estimate.

Your child will probably be familiar with many of these kinds of games. However, he may not have discussed his *reasoning* with anyone before this. It is very important that you use this session to talk to him about how he went about guessing or making his decisions.

If you listen to his explanations carefully, in essence he will tell you that he chose one marble or one spoonful of water as a standard to help him estimate the proportion of that part to the whole. Tell him that his reasoning is excellent and how he is using the idea of a *unit.* You can explain that whenever he has to estimate the proportions of something, *he can start by trying to find some kind of unit or standard against which he can measure the whole.*

Looking at Choices

In this section, you can show your child some different ways that artists have used their knowledge of proportions. First study figures 61, 62, and 63 with your child. Each one presents *illusions* of proportions that are often used in psychological testing.

Figure 64: "She was so happy now, because the toad could not reach her and she was sailing through such lovely scenes." Douglas Stewart Walker, *Fairy Tales from Hans Christian Andersen*.

After you have discussed each illustration with your child, explain that in each case the shapes are *exactly the same*. (You may want to check them with a ruler to be sure!) These illusions trick the eye because we expect to see objects in the distance drawn *smaller* in perspective rather than the same size. They are examples of how artists can manipulate our expectations, especially if they are very good at evaluating proportions.

Figure 65: Wanda the Scarlet Witch, "The Saga of the Serpent Crown," Marvel Comics. Is Wanda smaller than life, or are the serpents larger than life?

Imaginary Proportions

People have always been fascinated by dwarfs and giants because they make us see the world from a totally different perspective. The scale or size of the world becomes entirely changed.

Your child may be familiar with the story of Thumbelissa, also called Thumbelina. She was a tiny fairy child the size of a thumb who lived in a flower. Figure 64 from this original Hans Christian Andersen fairy tale, written 150 years ago, is a good example of a changed or *altered perspective.* Show your child where Thumbelina is riding on a lily pad, in the bottom right, dwarfed by the plants and the spider web above her. The scene would appear very natural if it weren't for the figure of Thumbelina, which alters the scale of the rest of the drawing.

Your child can perceive Thumbelina as a kind of *unit* against the whole scene and see that everything else must be either larger than life or that Thumbelina is much smaller than a human. Ask your child what clues he has about the relative sizes of subjects in this picture. Is she smaller than reality, or is everything else larger than reality?

In figure 65 we see a contemporary comic where the witch is dwarfed by a seven-headed monster. Ask your child to imagine whether she has become very small or whether the monster has become larger than life. In this case, it is easier to imagine that the *surroundings* are larger than life because monsters, unlike the butterfly, leaves, and fish in figure 64, are imaginary.

Looking at an Artist's Drawing

The simple line drawing of a row of dolls by American artist Beth van Hoesen in figure 66 is a good example of *realistic* proportions. Although there is no background or other subjects to give a clue as to the dolls' actual sizes, your child can see that they look realistic compared to each other.

Ask your child to rank these four dolls in order of smallest to largest. Then ask him how many times larger he thinks the largest doll is compared to the smallest doll. He can also look at the doll on the top left, and, using its head as a unit, he can imagine how many "heads high" this doll is. How many heads high are the other dolls? Take your time and help him compare their relative sizes by units.

USING PROPORTION IN DRAWINGS

The kinds of thinking your child will be doing in these exercises are similar to what he will always do now when he begins to draw: he will size up his potential subject and make some decisions about its shape and proportions before he begins to draw it. He will soon be surprised at how quickly he can do this.

Compare the proportions of these pairs of barrettes, pacifiers, and safety pins.

1. Comparing Pairs of Opposites

Help your child find pairs of objects for the following opposite sizes. Suggestions are given for the kinds of objects he might look for. You can help your younger child reinforce these words to distinguish the different proportions.

 a. Big/little (big rock, little rock)
 b. Long/short (long and short pencils or crayons)
 c. Wide/narrow (two different spoons)
 d. Hard/soft (sugar cubes, equivalent amount of loose sugar)
 e. Thin/thick (two different papers or slices of cheese)

2. Comparing Shapes

Explain to your child that when he has a pair of objects he can compare their proportions to each other. But when he has to compare *more* than a pair, he needs to use one thing as a unit against which he can measure the rest.

Have your younger child collect a series of subjects of the same size, such as a bucket of rocks ranging from very large to small. Have him place them in a row from largest to smallest, which will make a nice variation for him.

Talk about any differences you can see in their shapes. Talk about the textures of the different rocks, and look for dark and light textures. If he lines up the rocks on a table with a strong light on them, he will be able to study the shapes of their shadows as well.

Then have your child do a realistic drawing of this row of rocks. To help him plan ahead when he draws, encourage him to use a felt pen so that he has to make his decisions in his mind before he puts

Child's drawing of pairs of shoes with different proportions. Kathy, age nine.

them on paper. He could begin by using his smallest rock as a unit and deciding how many units larger each of the other rocks is.

Help your older child arrange a series of similar things with more difficult shapes. He may wish to line up a row of cars, dolls, or other collection of similar toys. Encourage him to first concentrate on the *overall* size or proportion of one toy to another, rather than on the details of any one.

Have him again use a felt pen and try to plan ahead. It would be very helpful if you could discuss each toy in turn before he adds it. Ask him, "Is the whole toy larger or smaller, wider or thinner than the last toy?" Then help him compare the sizes of the parts to the last toy. For example, ask, "Is the head smaller or larger? How does the shape of each part change?" The important aspects of this exercise for your child is his correct comprehension of the order of sizes and proportions and his ability to make drawings that are smaller or larger.

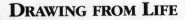

DRAWING FROM LIFE

When your child draws larger or more difficult objects from life, it is often useful for him to use a unit of measurement as artists traditionally do.

Figure 68: The arrows show three ideas for units to help you draw this truck.

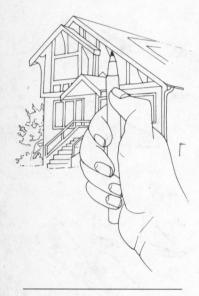

Figure 67: An artist uses his thumb and pencil to "sight" the proportions of a building.

He may be familiar with the sight of an artist holding a pencil vertically in one hand, marking a position on it with his thumb, and with one eye closed appearing to look past it to measure something in the distance. This technique of applying a unit is called *sighting.*

The unit of measurement the artist is using is arbitrary. That is, the artist picks any one part of his subject to use as his unit. For example, in figure 67 the artist's thumb marks the height of the second story. He can then use this height as his unit for measuring the height and width of other parts of the building.

1. Sighting

Choose an object that will have a fairly difficult perspective for your child to draw, such as a large toy truck. Sit side by side with your child and face the truck.

Decide which part of the truck you will use as your unit of measurement. There are many choices that could be made here, and figure 68 shows three of them. Have him choose one of these as his unit.

Have your child then close one eye and measure the height or width of this unit with his thumbnail on the pencil as shown in figure 67. Have him draw the length of the unit on his paper. He can

Nine-year-old Erin has made a careful study of the shapes and proportions of these toys.

now use that as a unit of measurement against other parts of the truck—either horizontal or vertical—and step by step he can add on sections of the truck, leaving the wheels and the details for the end. He can check each proportion as he works by frequently closing one eye and using his thumbnail measurement of the original unit against the new areas, to find out if they are larger, smaller, longer, or shorter.

2. Gauging the Proportions of a Subject to Itself

Tell your child that it is sometimes necessary for an artist to actually stop and measure or count the proportion of one area of a subject to itself.

For example, when drawing a portrait it is important to actually count the number of teeth that are showing, and then decide how wide the teeth are both in relation to the lips and to each other. It is easy to be tricked into an illusion, and it is not uncommon to see a row of 18 front teeth in a portrait or 30 petals on a simple six-petaled daisy simply because they *seem important.* Your child will find it helpful to have some experience in gauging the proportions of a subject to itself.

Have your child find some clothing that is patterned. The clothing might be striped, plaid, or patterned with a design. Have him look at the width of a sleeve and estimate how many stripes or patterns there are for that width. He could then actually count the number of stripes to see how close he was at gauging it. Have him also estimate the number of stripes on the collar, cuffs, or pockets. He might want to try guessing how many stripes wide the back of the shirt is across the shoulders.

An onion reduced layer by layer in proportion by Frank, age 15.

3. Reducing Proportions

Have some fun with this exercise for evaluating proportions that are "hidden." Choose an apple for each of you, and get ready with drawing papers and black felt pens or pencils.

Begin by drawing your entire apples. Draw two or three views of the apples, perhaps a top view, a bottom view, and a view showing the stem. Now take a bite out of your apples, and draw the apples showing the bite. You can eat more of your apples and do yet another drawing. Continue to eat and draw the apples until you are each drawing the cores. You can open the cores and draw the parts inside the cores, or line up the seeds and make designs with the seeds.

Talk about the parts of the whole with your child and how they all fit together. Talk about the relative proportions of the stem to the whole apple, the bite and the core to the whole apple, and the seeds to the apple and to the core.

ADDING ON

The Fantastic Dinosaur Game

Your child will enjoy drawing fantasy dinosaurs with you or another partner, using cues from the following lists.

The purpose of this game is to reinforce his vocabulary and his concepts of proportion, pattern, and texture all used together.

You will need to prepare four sets of eight cards each, about the size of business cards or playing cards. Cut some paper or lightweight card to these shapes.

Write the word *Proportion* on the back of the first eight cards. From the list, write one word listed under "Proportion" on the front of each card. Write the word *Pattern* on the back of the next eight cards. On the front write the eight suggested words for patterns. Prepare cards for "Texture" and "Body Parts" as well.

Proportion	Pattern	Texture	Body Parts
Larger	Spotted	Hairy	Head
Thinner	Wavy	Slippery	Tail
Wider	Striped	Bumpy	Arms
Smaller	Freckled	Spiky	Legs
Fatter	Zigzag	Gooey	Stomach
Shorter	Bordered	Furry	Back
Tiny	Scalloped	Rough	Sides
Enormous	Checkered	Soft	

When you are ready to play, you will also need some drawing paper and felt pens. Shuffle and turn each set of cards upside down. Take turns picking one card from each pile. You will both draw a fantasy dinosaur based on the descriptions given on these four cards.

For example, your first set of cards may describe the dinosaur as having a "larger [proportion] zigzag [pattern] spiky [texture] back [body part]." Your next set of cards may describe the dinosaur as having a "thinner spotted hairy tail." As you choose each body part and add on to your dinosaur drawings, you will have to use the "Proportion" card as a guide for its size in relation to what you have already drawn.

Eleven-year-old Jamie has drawn a fantasy dinosaur with a striped, zigzag tail and scalloped, hairy legs.

THE WORLD AROUND US

1. Measuring Sizes

Measure things around the house with a feather, and estimate how large or small they are. Begin by guessing, then use the feather to check your accuracy. For example, you may find that the television is eight feathers high or that the telephone is two-and-a-half feathers wide. Then measure with a sugar cube. You may find the television is, for example, 32 sugar cubes high.

You can measure subjects in your house with a baseball bat for a different kind of perspective. For example, the telephone may be one-quarter of a baseball bat wide.

2. Measuring Textures and Patterns

How many blades of grass are there on your lawn? Try to imagine, then count the blades of grass in a six-inch square corner and multiply this by the square footage of your lawn.

If your front sidewalk is marked by lines, estimate the number of sections to the end of your block.

On a car trip, estimate the number of telephone poles or yellow dotted lines to the next stop light.

Delicate patterns found inside an orange and a green pepper by Betty, mother.

3. Finding Hidden Patterns

Take a field trip to the grocery store and talk about what you might see if you opened different fruits. You could buy some for your child to peel or cut open at home.

He could draw designs of the different interiors and seed patterns and post them on the display board so family members can guess the kind of fruit he has drawn. Your child will discover some very interesting and often very beautiful patterns inside such fruit as kiwi or inside vegetables like peppers or tomatoes.

"I never have to look for things to draw anymore because I see them everywhere."

DEBBIE, age eight

Point of View

*F*ew elements of drawing offer such opportunities for creativity and imagination as *point of view.*

A point of view in a drawing is the artist's *perspective* or his position in relation to the subject he is drawing. Point of view is the very first choice that an artist makes before he begins to draw.

Children at play are the masters of point of view. Watch a young child with a large cardboard box. Through her play she will use it in a variety of ways. She will crawl under, over, and around it. She will climb into it and pretend she is in a car, boat, or train; she will upend it and pretend it is a table or a bed for her dolls. The purpose of this chapter is to help your child transfer her ability to explore points of view to a *drawing* context.

A point of view for the artist is, more than anything, about choice. There are dozens of points of views for drawing any given drawing subject, and the artist must choose only one.

A point of view that "works" does several things. It gives information about a subject in order for the viewer to identify it, and it shows the features or the character of the subject to best advantage. A good point of view enhances *illusionism* because it shows the subject from an angle that makes it look most three-dimensional. Most important, a point of view expresses a connection between the artist and his subject: it tells us something about his imagination, his sense of humor, or his creativity.

Birds Talking by Harpinder, age eight.

An unusual bird's-eye view of cars on the freeway by Kathy, age nine.

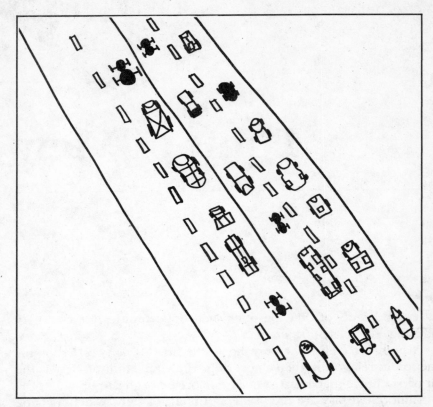

HELPING YOUR CHILD UNDERSTAND POINT OF VIEW

This section might better be titled "Helping Your Parent" because your child will probably be more familiar than you with point of view. You can participate at her level and give her the opportunity to show you how she visualizes her environment.

Begin by placing a simple straight-back chair in the center of the room. Tell your child that you are going to look at the chair from as many points of view as you can find. Set the framework for this activity by standing in front of the chair with her and talking about what you both can see. For example, tell her that you can see the front of the chair's back, the top of the seat, and the two front legs. Ask her if she can see the two back legs from where she is standing.

Move to the back of the chair and ask her what she can see from this view. She will probably tell you she can see the back of the chair and the two back legs and that she can see the seat through the back of the chair. Ask her if she could sit on it from this point of view. If she says no, ask her which part of the chair is closest to her.

Figure 69: The same crayon drawn from different viewpoints. Which crayon could you pick up and begin to draw with? Which drawings don't look like a crayon?

Marie's ball

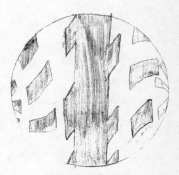

Robin's ball

By rotating the ball slightly, this mother, Marie, was able to show nine-year-old Robin how the same pattern could be used advantageously to make the ball look rounder.

Now move to the side of the chair. Point out where you can see the side edge of the back and two side legs. Ask her how she would sit on it from this point of view and what is closest to her.

Next, get down on the floor with your child. Lie on your backs and look up at the chair. Talk about how big the legs look and what you can see underneath the seat. Are there bolts holding the seat in place? How are the legs joined to the seat?

Have her count the number of points of view that you have looked at. She should remember a front view, a back view, a side view, and an underneath view. Ask her if there are any other views that she could take. See if she can find 12 different points of view, including the four views you explored with her.

Ask your child which view she would choose to draw. If she chooses a front or side view, ask her why. In her own words she may suggest that it gives the viewer the most "normal" information about the chair. If she would like to draw the chair upside down because it makes a good view, ask her why. Would it be a challenge for her to draw? Would it be dramatic? Would it reveal things that people haven't seen before? You could ask her if she thinks people would understand *why* she has drawn the chair from this angle and then suggest that a combination of an original view and an informational view might work the best.

Figure 70: *Pigs,* Pablo Picasso, charcoal.

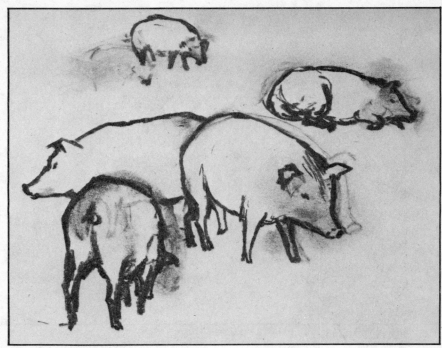

LOOKING AT CHOICES

Looking at Different Points of View

Show your child the illustrations of different points of view of the same crayon in figure 69. The artist has drawn this crayon from many different vantage points, giving us everything from a side view to an end view. Ask your child to identify the point and the end in each and tell you which is closest to her. Which drawing most accurately portrays a crayon and shows that the subject could be nothing else *but* a crayon? Then ask her which drawing appears most three-dimensional or illusionistic; that is, which crayon could she pick up and begin to draw with? Ask her which crayons appear to be in motion as if they were writing, and which crayons appear to be very *stationary,* or not moving. See if she can think of any more views of a crayon that the artist has not drawn.

Looking at an Artist's Drawing

Pablo Picasso was a very famous artist of this century because he tried to see how far he could go with different subjects, both real-

Figure 71: *Woman in a Blue Dress,* Pablo Picasso.

istically and to the point where his pictures became abstract. He was extremely inventive and imaginative in all of his explorations. However, Picasso's major interest was in point of view.

When he was young, he liked to draw things such as the pigs in figure 70 from a realistic point of view. We don't know whether Picasso changed his point of view of one pig several times or if he drew an actual group of pigs, but the end result is pigs seen from many points of view. Ask your child to describe her view of each pig, and talk about what it is doing. Which ones look as if they are moving or about to move? Which ones look as if they are resting? Which ones are closer or farther away?

Which view shows the bottom of the cup? Which one has the narrowest opening?

When Picasso was older he became very interested in making pictures that showed *simultaneous* viewpoints, or several viewpoints all combined in the same drawing. At first, he still drew a number of subjects from different viewpoints all in one picture, and then he gradually began to simplify their shapes and forms. Eventually he became interested in seeing what would happen if he just drew *one* thing, but *as if* it were seen from a number of viewpoints all at the same time. This style became known as cubism. This was a very unusual choice that he made, but this was his choice, and he felt that it gave a truer picture of what a subject was like than just one viewpoint. Figure 71 shows a cubist drawing with simultaneous viewpoints.

See if your child can identify the following: two views of the woman's mouth, two views of her head (front and sideways), four hand positions, and two views of her chest and collar.

Encourage your child to use prepositions such as "down on it," "from beneath it," "over" or "under" it to describe her viewpoints. Ask her how many different viewpoints she can find in this drawing.

USING POINT OF VIEW IN DRAWINGS

1. Choosing Points of View

You will need a set of simple coffee mugs or tea cups that match: three cups for a younger child and five or more if you are working with an older child.

Although he had not attempted such a drawing from life before, twelve-year-old Jim produced these impeccable views of his sneakers in minutes. Your child might like to draw a whole series of patterns found on the bottoms of different family shoes.

Give your child one cup at a time, ask her to place it in front of her on the table, and choose a point of view. She may choose a simple side view for her first one. Continue to give her cups and have her line them up next to the first one, placing each one in a different position.

Talk about how much of the cup she can see for each position. Different views will show the front, the back, the side, the handle, the top of the handle, the inside of the handle, the inside opening of the cup, or the bottom of the cup.

Have her count the number of views that she has arranged and ask her to memorize the different viewpoints. Then cover the cups with a towel, and bring out a new cup. Ask her to hold the new cup at different angles and tell you all the different views she sees of the cup. Count the views for her. Then remove the towel from the row of cups and see if she has forgotten any views.

2. Drawing Front and Back Views

Even the youngest child will delight in this exercise in which she can draw her favorite doll seen from the front and again from the back. Have her use two separate pieces of paper, one for each view of the doll.

Figure 72: To compare your accuracy, line up the drawings on the glass with the drawings on paper.

First talk about the proportions of the doll that remain the same for both drawings. Point out the shape of the doll, for example, its squarish body, its round head, or its long narrow arms.

Have her do simple line drawings of the doll first. When she is finished she could add more details for features or for clothing. The older child may wish to go on and place the doll in different poses in order to add a series of views to her drawing, much as Picasso did with his views of pigs.

DRAWING FROM LIFE

In the following exercises your child will again be tracing through glass as she did in chapter 1. This time she will be using the glass as a way of checking or correcting her proportions and her point of view after she has drawn from life.

She will need a piece of glass about eight by ten inches. If the edges are sharp, cover them with masking tape. Your child will also need a water-soluble felt pen, some damp paper towels for cleaning the glass, and some drawing paper.

1. Drawing Different Points of View of a Daisy

For this exercise your child will need a common daisy, either real or fake. Other good subjects would be a spool of thread, an electric plug, or a small box.

Have your child select a point of view and place the daisy on the table in front of her, with her drawing paper between her and the daisy. Have her begin analyzing her point of view by closing one eye and tracing around the outside of the daisy in the air until she gets a feeling for its shape. Then have her hold her pen over her paper and make a drawing of that point of view in the air just *above* her paper. When she feels she is ready, encourage her to now make a real drawing on the paper with exactly the same view.

Have her turn the daisy to a new point of view and repeat the process. Encourage her to draw at least three different points of view, showing more or less of the center of the flower each time.

To check the accuracy of her drawings, she can draw them again on the piece of glass. She will hold the piece of glass upright in front of her with one hand, close one eye, and use her felt pen to trace her views of the daisy right on to the glass. Have her repeat the same views of the daisies that she drew on the paper, matching the viewpoints as closely as possible.

She can now stand up, hold the piece of glass horizontally above the drawing, and line up each drawing on the glass with the matching drawing on the paper. Closing one eye, she can lower and raise the glass until the two flowers match up in size (see figure 72). The drawing on the glass will probably be smaller than the life-size drawing on her paper, so she may find that she needs to hold the glass several inches above the paper until they appear to line up in size. Have her notice where she has been accurate in her assessment of her viewpoint and proportion and where she may have miscalculated.

She may then wish to put the glass aside and try drawing more viewpoints of the daisy. Remind her to go through the steps of tracing around the daisy *in the air first* to develop a feel for its shape and size and for her view before she begins to draw it.

2. Drawing a Room Interior

You may wish to try this more ambitious drawing with an older child, although children as young as five can present a very unique point of view.

After drawing all the long lines, nine-year-old Sandeep copied the patterns of his walls and wallpaper.

Take your journals into the kitchen or the living room and sit in different corners of the same room. Begin by looking for the largest lines in the room. In the kitchen this may be the lines for the corners of the walls, or the edges of cabinets, or large appliances like refrigerators and stoves. Draw these lines first, and complete your drawings by adding such details as sink faucets, towels, calendars, or kettles on counters.

When you have finished, trade places and draw the other person's view. Don't look at each other's drawings yet! When you are finished you will be able to compare your similar points of view and see what each of you noticed.

The younger child will probably not be able to do this exercise exactly as described, but she will be interested in the "narrative" of the environment or the details that tell the story of your lives, such as the dishes, books, aprons, and sentimental objects. She may even go so far as to add imaginary people eating, washing dishes, or opening the refrigerator. Praise her for drawing a type of scene from life that she might normally not attempt. This may have been her first opportunity to try drawing a "real" scene, rather than one from her imagination.

ADDING ON

Drawing Under Pressure

Ask your child if she would like to see how many drawings she can make under pressure using different points of view. This is an excellent game for unblocking creativity in self-conscious adults and groups of children.

Present her with a banana, 12 sheets of paper numbered from 1 to 12, and a range of drawing mediums, for example, a felt pen, a pencil, pencil crayons, and charcoal. Tell her that she can use any style, any point of view, and any kind of abstraction she wants, such as a drawing just of the seed pattern inside the banana, but encourage her to begin by drawing several views of the whole banana.

Set a timer for exactly 10 minutes, and tell her she will have 10 minutes to do 12 different drawings. She can consider each one finished when she feels her idea is over. The drawings need not be extremely detailed or realistic. If your child gets stumped during the 10 minutes, be sure to suggest a new drawing medium or a new view, such as a peeled banana or a bitten banana.

When she is finished, or when the timer goes off, have her line up the twelve drawings in a row. Ask her to describe to you what she was thinking as she did each one and when and why she changed to a new drawing.

Six "pressure" drawings of a banana in different mediums.

THE WORLD AROUND US

Children love the opportunity to change their point of view. Here are some suggestions.

1. Points of View Outside Your House

How many views of your house can you find?

Walk around your house at a distance and discuss your different viewpoints of it. There may even be a side of your house you have never walked past because it is blocked by stairs or shrubbery. Try to squeeze in and see what it is like there.

Ask the people who live across the street or next door if you can come over and look at your house from their house. Look in all your windows and talk about what you see.

If you live in an apartment building where all the apartments are designed the same way, ask a neighbor if you can come over and see how she arranged her furniture differently from yours.

2. Points of View Inside Your House

Change your perspective inside your house.

Trade beds with your brother or sister for the night to see what it is like to wake up from his or her point of view.

Have everyone change places at the dinner table for one night, or midway through the meal change places.

Ask your parent if you can sit in his or her favorite chair for one evening to read or watch television.

Lie on your dog or cat's mat for 10 minutes and watch very quietly. What can you hear? Do you feel any drafts?

Crawl along the floor behind a baby or a pet for 10 minutes. Copy everything they do.

The point of view in this shaded charcoal drawing makes the dog look both sleepy and watchful.

What does your dog see when he looks up at you?

"You can draw pictures that you'd like to see."

HARMAN, age six

Movement

*T*here are many traditional elements of drawing, such as texture, tone, shading, and point of view, that are often poorly managed in children's drawings. The purpose of the earlier chapters was to help your child fill in some of the gaps in his knowledge. However, one element rarely seen in *adults'* drawings, and which is very common in the drawings of young children, is that of *movement.* It is very sad to see this element phased out at an early age as drawings of movement are possibly the most charming and imaginative of all.

Unlike adults, children cannot imagine that movement can't be drawn. Since they are still open to the possibility, they are far more creative in their approach to solving problems of movement in drawing. Young children will often try to create equivalents by physically moving their pencils rapidly in the area of moving parts, like a bird's wings or waving hands. Older children may break movement down into steps or sequences of objects in motion. There are many other choices that can be made, including the use of diagonal lines and shapes; repeated lines or concentric circles to show movement outside shapes; and blurred areas, such as we have become accustomed to seeing in photographs of moving figures.

A Bird Flying by Karen, age six.

HELPING YOUR CHILD UNDERSTAND MOVEMENT

If you keep a file of your child's drawings, this is a good opportunity to go through them with him and look for drawings of movement.

The changing diagonals of his "ground" line keeps eight-year-old Kamal's repeated figure on the move.

This inventive drawing by five-year-old Julian shows the swinging figures encased by curves of air.

One common element of movement is the *diagonal*. Because it goes across the static grain of the horizontal and vertical paper, the diagonal conveys a sense of something traveling. Have your child help you look for the use of diagonals in his drawings to depict movement. A diagonal might be found in the lines of a leaning house or in lines of slanting rain, or a person leaning into a movement.

Another element of movement that you may find is *repetition*. In his early drawings your child may have doubled up or tripled up areas where he wants to create a sense of rapid movement, which is caused by the subject repeating an action over and over again. Have your child help you find these areas, and talk about his solutions.

Another element is blurring, or *changing the focus*. As long as something remains still, we can see it with sharp edges, but when it begins to move it is difficult to fix those edges with a line. Your child may use a blur at that point.

In the next section, you can find examples of each of these elements and explain any that he may not have tried. Because these are all very common ways of expressing movement, they are called *conventions*. That means that most people will understand what he is trying to express when he uses them.

LOOKING AT CHOICES

Figure 73 shows the use of diagonals to express movement. Have your child find all the things that are leaning in this windy day scene: the tree trunk, the branches, the little girl, and her scarf. The car-

Figure 73: An example of movement expressed through diagonals in a drawing by Faith, age nine.

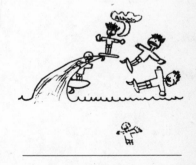

toonlike lines in the air around the falling leaf are a *convention* that tells us the leaf is blowing or falling.

Figure 74 shows the use of repetition to stand for movement. In this example, a series of repeated figures shows a surfer falling off the top of a wave. Ask your child how he might have made this picture more realistic. Where would the surfer be looking if he were falling? What direction would his arms and legs be facing?

Study figure 75 with your child, and show him where the subject blurs at the points of motion. This lively charcoal portrait combines areas of light and dark, shading, and blurring to give a strong impression of conversation and laughter. You can almost "feel" the head nodding, the mouth opening, and the eyes crinkling. Look at the groups of diagonal lines in the hair, forehead, and neck areas as well. Have your child trace these diagonal lines with his finger.

Figure 74: An example of movement expressed through repeated forms by Michael, age eight.

Figure 76: *Japanese Rain on Canvas,* David Hockney, acrylic on canvas.

Looking at an Artist's Drawing

In chapter 2 your child studied two drawings by California artist David Hockney. Each showed a pattern of light and dark palm trees against a wall. In figure 76, your child can see how Hockney made a repeated pattern with lily pads and lines of rain. Although the forms are again very simple, Hockney has created an intense feeling of depth and density. You can discuss how he did this with your child.

First show your child how Hockney uses two traditional conventions for movement: the diagonal lines of the rain and the concentric circles in the water. Have him feel the angle of the rain lines with his finger and trace around the circles in the water where the rain hits it.

This picture is especially successful because Hockney has done some key things with light and dark design to make the picture feel *deep.* For example, show your child where the diagonal rain lines change from dark in the foreground to light in the background, as if

the sunlight is hitting the falling rain and making it appear like silver streaks. This change from dark to light lines creates a sense of depth, as does the diminishing size of the lily pads from foreground to background.

Have your child compare the size of a lily pad in the front to a lily pad in the back. He will find that the lily pad in the background is not only *smaller* but *flatter* or less round.

Show him how the diagonal lines of rain also become much *closer* together in the background. These are conventions for creating an illusion of distance, which you will study more closely in chapter 10.

The concentric circles in the water make another mix of light and dark lines. Show your child where they overlap each other and the lily pads, creating yet another layer of pattern.

Your child will find that it is difficult to fix his eyes on any one point of this picture. The many areas described above are competing for his eyes' attention. A skilled artist like David Hockney can create a feeling of movement by using different elements in ways that make your *eyes* want to move or travel about his picture. Explain to your child how his eyes want to move from foreground to background and around the picture again, from the sunlit areas into the shadows to examine the details, and then back out again into the light. This is a masterly composition both of light and of dark, of pattern, and of movement.

Using Movement in Drawings

In this session, your child can use his imagination to come up with some creative solutions for the suggested movements. You might recommend that he try line drawings of each with a felt pen and then experiment with a pencil that he could use to smudge or shade his lines. He could also try drawing each one with a water-soluble pen and using a brush to "wash" in a feeling of movement with water.

1. Imagining Movement

Discuss different ways to make the following subjects appear to have motion through using diagonals, repetition, or blurring, and then have your child divide his drawing paper into six rectangles. He can draw one of the following subjects in each rectangle.

 a. Bicycle wheel turning **d.** Flames burning

 b. Wind blowing **e.** Lawn sprinkler

 c. Rain falling **f.** Popcorn popping

2. Imagining Slow Movement

Challenge your child to draw the following very slow movements. If he isn't happy about his results, then ask him to challenge other adults and children until he has an idea. These three movements could form the basis for ongoing "research" as there is no right or wrong answer. He might like to collect drawings done by different people that show the same slow movements, and display them on his board for comparison.

 a. A flower opening

 b. A snail crawling

 c. A cake rising

DRAWING FROM LIFE

In the next session, you can study the *stages* of movement with your child. The human figure has been chosen as the subject for several reasons.

 First, your child can position himself in different stages of movement in order to actually *feel* how they change. He can close his eyes and feel how he holds the different parts of his body, or he can look in a mirror and see how the parts of his body appear in different positions. He can use you as a convenient model to see how your shapes and positions change. Finally, you can take turns modeling for each other and *compare your experiences* holding or drawing a position. You will also be able to sustain or repeat a position for each other as often as necessary.

 Your drawings will be smaller than life, and you can either use mirrors or model for each other to get your proportions right. You could also take turns tracing your positions right on the mirror with a felt pen, or through glass, to check for accuracy.

1. Feeling the Stages of Movement

Before he draws, have your child *feel* how his body moves.

 Pose your child sideways in front of a mirror. Ask him to pretend to run in very slow motion on the spot. How slowly can he run while still moving? Point out how he is moving his arms up and down, and

Drawings by children age six and seven of . . . a bicycle wheel turning, wind blowing, rain falling, flames burning.

show him how his knees are bending and straightening. Then ask him to try and freeze in a position.

Study his position with him and describe how all his "parts" are held. Compare them to each other. Is his right side moving together, or is his right arm bending at the same time as his left leg? Ask him to "feel" his body shape. Is he leaning forward?

Take turns and model for him. Run in slow motion and ask him to describe what your arms, legs, body, and head are doing as you run.

2. Drawing the Stages of Movement

Have your child draw a series of figures that shows a person getting ready to dive off a board or jump over a vault. If your child loves to draw a certain animal, such as a horse, have him draw a series of pictures with a rider and horse jumping over a hurdle.

He could plan on drawing five stages of development. Talk about what position the body would be in to start, and help him analyze the first kind of movement that the form would make. Which parts of the body would bend first? The third drawing should show the figure well into the movement, and the fourth and fifth drawings should complete the movement.

ADDING ON

Modeling from Different Points of View

Model for your child so that he can draw you from three points of view. Stand or sit in a position that you can easily hold for six minutes, and set a timer for two minutes for each view.

Two series of drawings by children that show the stages of movement. *When I Went Skiing* by George, age 10, and *My Dog Stealing a Cookie* by Patti, age 7. Look at the expressive negative shapes between the dog's legs.

Figure 77: Can you identify the subject of this photograph? What clues do you have?

Have your child draw you from a *side* view, allowing two minutes for this pose, then have him move so he has a *back* view of the same pose, and allow him two minutes to draw this. Then have your child move so he is sitting or standing in front of you, and have him draw a two-minute pose from the *front.*

If he is having difficulty drawing you in any one of these poses, wait until he has finished all three drawings, and then check your pose in a mirror and compare it to his drawing. See if you can find the areas where he is having trouble, and show him how your "shapes" have become different. You may notice, for example, that the *proportions* of your form have changed and less of your leg or arm is showing. Or you may find that the point of view shows something new, such as the bottom of your foot or the palm of your hand, which the other points of view did not show. Look for negative shapes made inside bending arms or legs.

THE WORLD AROUND US

Have your child try the following activities for recording movement.

1. Charting the Flight of a Bird

Look for a bird outside your window or in your yard. Put your pencil on a piece of drawing paper to show where the bird is resting.

As the bird flies or moves about, move your pencil on the paper to record the directions and lengths of its flight or movements. If the bird leaves the paper, wait and begin with a new bird, or use a new piece of paper when the bird has come to rest again.

2. Photographing Movement

Take photographs of different moving subjects such as fire, a fish swimming, or water pouring out of a tap.

If you have a 35mm camera use a fast film like ASA 400, and set your camera at a shutter speed of 125 or above to freeze the action. The higher you set the shutter speed, the faster an action you can freeze. For example, a race car may need a shutter speed of 1000 to freeze the action, while a jogger may only need 125. In both cases, you will see a blurred background in your photographs, which shows that the subject was moving.

When you look at the finished photographs, you may find that some stages of movement, such as a bird in flight, look very peculiar. Although they are realistic (your photograph is proof), they don't make very good photographs and they wouldn't make very good drawings, because the shapes are unexpected or *out of the normal context.* Talk with your child about the kinds of views of movement that work or don't work. You can use figure 77 as an example.

Twelve-year-old Sandra has drawn three views of her father. Study the different shapes made by his legs in each view, and compare the length of his left leg in the side view to the length of his left leg in the front view. Why is it "shorter" in the front view?

"I want to be an artist when I grow up. I can make pictures for my mom."

JACKIE, age seven

Distance

*I*n addition to the concepts of proportion and point of view, the concept of *distance* is one of the most formal or learned elements of drawing.

As your child has learned in the chapters on line and shape, lines and shapes do not really exist in the actual objects. They are devices that an artist imagines and uses to *stand for* three-dimensional things on flat, two-dimensional paper. The rules for giving subjects a feeling of depth and distance in a drawing are similar devices. Children can easily learn how to use the rules of distance when they draw to make their subjects appear to have depth and distance. It is mainly a matter of teaching your child to plan ahead so that subjects both overlap and diminish in size as they recede.

Young children do not have any awareness of these rules or conventions. They are mainly interested in the meanings and actions of their subjects as they draw them. It is important to them to develop a story, with identifiable figures and actions, but they don't plan their story in advance. Their drawings usually begin with an intention to represent a figure, feeling, or place, and from this initial intention they embellish or add on to their figures and scenes with a kind of story that develops as they draw.

It is fascinating to look at the maneuvers and manipulations that children do make in their drawings in order to take the concept of distance into account when it becomes necessary. It is not unusual to see layers of overlapping subjects actually scribbled right on top of

By drawing the bat's head first and the wings behind it, seventeen-year-old Adam has created a feeling of depth.

135

A careful felt-pen study
of overlapping shapes by
Luis, age 13.

each other in very young children's drawings. Older children are frequently unwilling to overlap their figures, preferring to keep each object clean and separate. It is not uncommon to see "mirror reversals" or subjects floating in skies in the drawings of older children.

In this chapter, you can help your child become aware of some of the rules, or conventions, for representing depth and distance. She will find that she is naturally combining many of the elements of drawing learned earlier. If your child has difficulty drawing the subjects suggested in this chapter, you will be able to help her evaluate the *kind* of difficulty she is having—one of proportion, shape, or point of view, for example—and review that element with her.

HELPING YOUR CHILD UNDERSTAND DISTANCE

The most important elements of distance are *overlapping* and *diminishing size.* You can begin your explanation of these elements by talking to your child about the things in the room that are close to you and those that are farther away.

Sit side by side on the sofa or on chairs, and ask your child to tell you what is closest to you. Start with the subjects directly in front of you. Is there a coffee table in front of you? What else is between the wall facing you and the sofa where you sit, besides the coffee table? Ask your child to list everything between the far wall and the sofa where you sit, and help her put them in order from the closest to the farthest. She can hold a yardstick out to help her.

Explain that she has now measured the *real* distances of subjects from her, but that when she draws she has to use *drawing* distance. Tell her that two things will happen when she uses drawing distance. First, the subjects diminish in size, and second, they overlap. Both are

This drawing shows both sides of a street, with one side flipped upside down. This seven-year-old has no concept yet of overlapping buildings to represent distance.

This drawing shows a dog being walked in the sky. The six-year-old artist wanted to show the dog being walked behind him.

Figure 78: Close your eye and use two fingers to measure the diminished distance of objects across the room.

easier to see if she closes one eye, because both eyes give us depth perception. When we *see* "flat," it is easier to *draw* "flat."

First, you can show her how things diminish in size as they are farther away. Have her close one eye, and use her thumb and forefinger to measure the heights of different subjects in front of her. She will be familiar with the surprisingly small heights from her exercises drawing on glass. You can place two identical subjects, such as cups or chairs, in front of her, one very close and one a few feet farther away. She can compare the diminished size of the farthest by measuring it with her thumb and forefinger.

By moving the car from its first position in a line with the house and drawing the car so that it overlaps the house, this nine-year-old has dramatically increased the feeling of depth in her picture. However, the subjects are still drawn in a row along the same ground line.

Second, you can explain that when she uses distance in her drawings, the subjects closest to her will *overlap* or partially cover the subjects farthest from her. The older child can close one eye and put her hands up like a mime to feel an invisible "window" in front of her. Ask her to show you how low or high each subject she sees is on the "window." She should be able to correctly order the things closest to farthest away from her as lowest to highest on her window. You can then discuss how each "low" subject overlaps the next "highest." For example, the coffee table would overlap furniture farther away or behind it, and the furniture would overlap the far wall. She might even want to try tracing them on a piece of glass to check how they overlap.

Once she understands these concepts of low, high, and overlapping, you can compare her window to a piece of paper. The rules of drawing distance are simply that what is closer—or in front—is *lower* on the page, and what is farther away—or behind—is *higher* on the page. The subjects in front are proportionately larger and must be drawn first; the subjects behind them are proportionately higher, smaller, and drawn last.

LOOKING AT CHOICES

Looking at Composition

Figure 79 shows a drawing of toys overlapping. Ask your child if she can name the four toys in the drawing and tell you the order in which they overlap. She should be able to see that the doll in front overlaps the bear behind it, the bear overlaps the airplane behind it, and the airplane overlaps the drum at the back. Ask her if she thinks this is a good point of view for drawing these toys. She may suggest that the artist move each toy to one side or the other so they are more spread out. Tell her that she has solved a problem of *composition,* which means how to arrange different things in a group.

Figure 80 shows the same group of toys spread out. Ask your child if she can tell what is wrong with this drawing. She may say that the doll and the bear look "flat," or they are all too spread out along the bottom of the page. Ask her how she would change this composition. Encourage her to see that if she moved the bear, the airplane, and the drum farther up on the page they would look farther apart and that there would also be room for their *volume* or depth.

In figure 81 each toy is drawn a different distance from the bottom of the page, and they are separated enough *sideways* so that they don't overlap too much.

Figure 79: These toys overlap too much. (Above)

Figure 80: These toys don't overlap enough. (Above right)

Figure 81: This composition works better. (Right)

Looking at an Artist's Composition

Show your child figure 82 and explain that this scene of the Three Wise Men on their journey to Bethlehem was painted on the wall of a chapel inside a palace around 1460, more than 500 years ago. By comparing the proportions of different subjects, she can see how the artist gave his picture depth.

The Three Wise Men on horseback are the closest subjects. Have her find them at the bottom of the illustration. She can compare the size of the Wise Man on the left to the size of the hunter on horseback in the middle of this picture. She will see that the rider in the front is more than three times as big as the hunter in the middle. This shows that the hunter is very far away.

Have her also compare the size of the forest trees behind the other two Wise Men to the size of the same kind of trees in the top

Figure 82: *The Journey of the Magi to Bethlehem,* Benozzo Gozzoli. Can you memorize everything the Wise Men would pass on their journey up the mountain?

left of the picture. The forest trees are almost four times as high, so they appear much closer.

Ask your child to list all the different subjects she can see, starting at the front, or *foreground,* and working her way to the *background.* You could then play a memory game with her, and ask her to describe by memory everything the Three Wise Men would pass if they journeyed up the mountain.

Eight-year-old Balinder has drawn both his man-eating crocodiles and his trees smaller in the background and a good distance up the page to give his scene a feeling of depth.

USING DEPTH AND DISTANCE IN DRAWINGS

Your child has learned several new and difficult concepts in the previous sections, and you can now help her reinforce them with some active projects. You will be collecting pictures of subjects to combine together in a scene. This will give you an opportunity to discuss how the pictures overlap each other and how the sizes of the subjects diminish with distance.

1. Collecting Subjects

Begin by finding pictures of the subjects, suggested in the margins, either in magazines or in old storybooks.

The older child will be able to help you cut them out or may like to draw some of them for himself. With a younger child, you could search for the subjects one category at a time. For example, if you are looking for subjects in the "Vehicles" category she can help you find the kinds of vehicles that travel on sidewalks, streets, water, or in skies.

Ideas for Subjects in a Scene

Buildings	**Trees**	**Vehicles**
Houses	Large and small trees	For sidewalks: tricycles and wagons
Office buildings	Trees with and without leaves	For streets: cars and trucks
Post offices	Bushes and hedges	For water: boats and ships
Hospitals		For skies: airplanes and helium balloons
Churches		

Structures	**Landscapes**	**People**	**Animals**
Fences	Mountain ranges	Large and small people	Dogs
Bridges	Forests	Walking	Cats
Telephone poles	Rocks	Pushing things	Birds
Streetlights	Clouds	Riding things	Butterflies

2. Using Diminishing Sizes

Have your child choose one picture from each category, and have her arrange them in a scene on a blank sheet of 8½-by-11-inch white paper. Don't fasten them down.

Tell her that the person from the "People" category will be her *unit,* or standard of measurement, for the other pictures. She will have to compare the relative sizes of each picture to the person.

If, for example, a dog is larger than it should be for the size of the person, then the dog will be *closer* than the person. Have her place the dog closer to the bottom of the paper than the person.

If a tree picture is smaller than it should be for the size of the person, then have her place the tree *farther* away from the person or higher up the paper.

3. Using Overlapping

As she arranges the pictures by sizes, you could also discuss how they might overlap so all the different subjects seem as if they belong to the same scene.

Show her how a scene could be made starting from the top of the paper and working down, placing the subjects in the distance first. Have her choose several pictures for the distance, such as an airplane, a mountain range, and clouds, and arrange them at the top of the

A group of primary students added texture and detail to their magazine collage of a journey. How many added textures can you find in this section of the mural?

paper. Then have her choose subjects for the "middle" area, such as buildings, trees, and streetlights. She can finish by placing the closest subjects, like a butterfly, fence, or a person, in the bottom area of the page. Help her move the picture around and talk about how the different subjects would overlap in places.

4. Making a Picture of a Journey

Begin this project in a new session or plan it over two sessions as you will want to give your child lots of time. This is a perfect project to begin during a snowstorm, an illness, or a rainy long weekend.

The size of your mural will depend on the age of your child and her concentration level. You could allow five minutes per year of your child's age for the length of each session, and estimate the size of the mural on this basis.

She will need a long roll or strip of paper that you can tape or pushpin onto a wall at a height suitable for your child. She will also need a glue stick and some colored pencils or felt pens.

Your child will be arranging the pictures on this paper to make a sequential story of a journey somewhere. Different events will occur as she arranges the pictures from left to right and the landscape may also change. You are giving your child an opportunity to develop a story of her own using the pictures you have cut out, and she can imagine the sequence of events as she works. This will give her the opportunity to apply what she has learned about the rules of distance, plus satisfy her interest in developing a story.

Have her start on the far left of the roll of paper and choose some pictures for the background, middle, and foreground. Talk about their relative sizes and how they might overlap from the top down. She can use the glue stick to attach them to the paper and use the colored pencils and pens to add more scenery between the pictures, like sidewalks, roads, wavy lines for water, or more fences. She can continue to add pictures and drawings as she continues on her "journey" from left to right. When she has glued on all the pictures, she could go back and add textures and patterns such as grass, shingles, or cement to each area, drawing their particles proportionately smaller with distance. She could add patterns for rain or snow in different areas, and give the people umbrellas and boots.

The older child could add shading to places like street curbs, telephone poles, and cast shadows. Ask your child to also show you where different pictures are "moving," and suggest that she add lines or shading to show the movement. The older child can be encouraged to actually draw as much as to place the pictures or even to draw the pictures *instead of* gluing them on. This will give her a chance to look more closely at their underlying shapes and proportions.

Be flexible and allow your child lots of room for creativity with this project, as it could take off in many different directions. She will be thrilled to walk a friend or family member through her story and later explain all the events.

DRAWING FROM LIFE

In chapter 1, you helped your child choose a view out one of your windows and showed her how to close one eye and trace the different kinds of lines she saw on the window glass. Since that time, your child has learned many new ideas about drawing. Her choice of

What "time" is the angle of this roofline?

view may now depend on what she has learned about point of view, as well as texture, pattern, and light and dark. She will be able to assess shapes and proportions herself and know how to give the subjects she sees a feeling of depth and distance. In this session, you can encourage her to join you in drawing in your journals a view out a window of your house using felt pens or pencils.

1. Choosing a View

Ask your child to choose two or three windows with a view, and discuss each view in turn with her. Tell her that she will be drawing a view that has many subjects closer and farther away and that she can pick the best one.

Begin by standing beside her, looking out the first window, and asking her to name all the subjects she sees. She should start with the subject closest to her (even the window sill), and then name each subject in turn *moving away from her*; for example, the lawn or the sidewalk directly below the window, the yard or the street on the other side of the sidewalk, and the buildings, trees, sky, and clouds moving farther into the background. You could ask her to imagine that she has a giant yardstick to help her decide which things are closest to her. Or she could imagine the scene as a giant pop-up card, with a series of standing cutouts moving away from her. You can use figures 83 and 84 as an example of this concept.

2. Drawing a View

When you have chosen the best view, *you will both begin by drawing the subject closest to you near the bottom of your paper.* That may be the edge of the window sill, followed by the wall under the window, then the window glass and the frame. Or you may wish to begin with the closest subject on the *other* side of the glass.

As you draw the subjects in order from closest to farthest, you will add them to your drawing from the bottom of the paper up, and the closest subjects will overlap the farthest.

You can help your child check the diminishing sizes of the subjects in the distance in several ways. She could close one eye and measure their height with her thumb and forefinger, or she could hold her thumb on her pencil and choose something as a unit of measurement to compare different proportions. She could also close one eye and actually mark the sizes on the window with a felt pen.

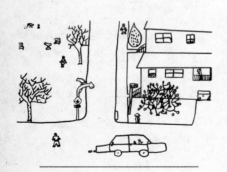

Eight-year-old Joanie's view tells a story of her neighborhood. What are the people doing?

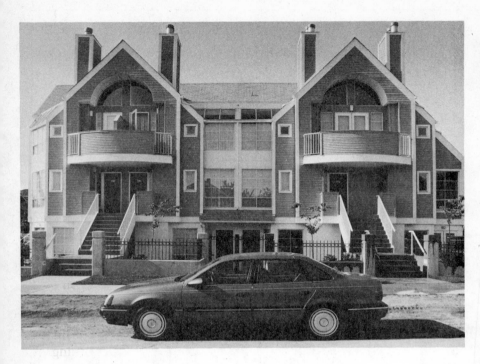

Figure 83: A photograph. Imagine a scene as a giant pop-up card with a series of standing cutouts.

Figure 84: A pop-up photograph. This car is closest, then the fence and the trees, followed by the stairs, the balconies, and the peaks. The rest of the house and the sky are behind them.

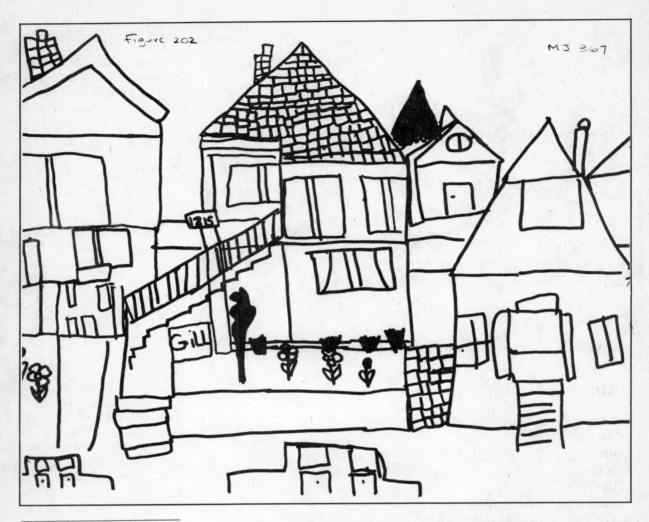

A view from her window by Jagdeep, age nine.

Encourage your child to concentrate on drawing all the long lines and large shapes first. When they are all placed, or "composed," she can go back and add details like texture and shading to them. Remind her that it is good to plan and develop a drawing in these stages, much as she layered her mural.

If your child has trouble drawing diagonal perspective lines in subjects like rooftops, staircases, or sidewalks, you can ask her to close one eye and "draw" the angle in the air. Tell her to compare this angle to the hands of a clock. Is it, for example, a "two-o'clock" line or a "seven-o'clock" line?

When you have finished your drawings, your child might like to trace the view right onto the window as she did in chapter 1, and compare her window drawing to her drawing on paper. You can discuss any changes in point of view, proportion, or depth with her.

THE WORLD AROUND US

Making a Storybook

Make a storybook to give to a younger child or to Grandma.

Use four pieces of a lightweight card, five by seven inches each, and draw the story of a journey you took. Your story might be about a visit to the dentist, a trip in your car, or an outing to the park.

Try to plan your story before you begin. How did you get there? Who did you go with? What was the first thing you saw when you arrived? Think about the order in which things happened while you were there. And how did you feel when you came home? You can draw each event on a new card, using both sides, and number the pages. The front of the first card will be your cover.

You will also want to plan each drawing from *bottom to top*. Begin each drawing at the bottom of the page by drawing the closest things to you. Behind them and farther up the page, draw the middle things. The closest things will overlap them. Finish by drawing what's in the background.

Have your completed cards laminated at a stationery store or an instant print shop. Punch three holes down the sides so you can tie the cards together into a book, or have the shop do a coil binding for you.

Her mother visits a beauty parlor in nine-year-old Faith's storybook. What is closest to you? What is farthest away?

Glossary

abstract Pictures or shapes based on real life that only partly reveal the original appearance.

angle A direction that isn't straight-on; seen from one side.

artist A person who is especially interested in visual ideas and appearances.

backlight A light coming from behind an object.

bond paper Ordinary white stationery paper.

border A pattern made by repeated lines or shapes along an edge.

composition The design or arrangement of shapes and forms in a picture.

concentric Inside each other, such as circles within circles.

conte crayon A soft cross between chalk and pastel.

contour line A continuous line that shows detail where the edges go in and out.

contrast Two different things beside each other in a picture. *Light and dark areas provide contrast in a picture.*

convention A device used to show something that is impossible to draw. *A bubble over a cartoon character is a convention that shows he is talking or thinking.*

curve A continuously bending line. A circle and an S are curves.

dense Very heavy or thick.

depth perception The ability to see depth, caused by each eye seeing a subject from a slightly different angle.

diagonal On an angle or a slant.

dimension The size; the height, width, or the thickness of a subject.

diminish Become smaller. *Objects appear to diminish in the distance.*

distance An effect caused by overlapping and diminishing size.

expressive The use of a wide variety of lines to show emotions.

fantasy From the imagination rather than from real life.

flaw A small unusual detail that makes an object more interesting.

focus All parts showing in clear detail.

foreground The subjects in front, or closest to you.

form A shape that has depth as well as height and width. *A form is three-dimensional.*

format The size and shape of a picture.

geometric Based on mathematical shapes and symbols. *A triangle, circle, and square are geometric shapes.*

grain The direction of a texture. *The grain feels rough one way and smooth the other way.*

gray scale Shows tones of gray between white and black. *The color red is in the middle of the gray scale.*

grid A pattern made by vertical lines crossing horizontal lines.

horizontal Across; from side to side, like the horizon.

illusion An appearance that tricks our eyes into seeing something that isn't true.

illusionism A strong impression of realism in a picture, caused by shading and point of view.

juxtapose Put two things next to each other; side by side.

line The mark or stroke made by a moving point.

mediums Drawing materials for making marks. *Pens and pencils are drawing mediums.*

modeling Shading.

motif A line or shape that repeats itself.

narrative A picture with subjects and details that seem to tell a story.

negative space The background; the shapes made by the air around objects or the holes inside them. *A cup has a negative space inside its handle.*

organic Living things like plants and animals; based on natural qualities. *Organic shapes could be seen in an abstract picture.*

outline A shape that shows the outside edge or silhouette.

parallel Running alongside each other.

pattern A line or a shape repeated at regular intervals.

perspective Your physical point of view or eyelevel.

point of view Your perspective or position in relation to another object.

positive shapes The foreground or nameable shapes. A cloud is a positive shape. The sky is a negative space around the cloud.

proportion The size or shape of one area or subject compared to another.

radiating Coming out from a central point, such as the radiating spokes on a bicycle wheel.

realistic A picture that appears like the real or original subject.

scale The size of one thing compared to another.

scalloped A pattern made by a row of half-circles attached to each other.

series A group of work that develops an idea.

shading An even gradation from light to dark gray, or vice versa.

shape A space enclosed by a line or a background. A shape is two-dimensional; it has width and height.

sighting Using a unit to calculate the size of something in the distance. *An artist uses his thumb as a unit when he is sighting a building.*

sketch A loose, quick drawing to capture an appearance.

static Stationary; not moving. *A diagonal line suggests movement but a horizontal line is static.*

structure The underlying shape or design.

style The consistent appearance of a recognizable technique. Picasso used many different styles.

swiveling Back and forth; from side to side.

symbol A mark, shape or a color that stands for something else. *The color red is a symbol to stop.*

symmetry Balanced; both sides are the same, such as a mirror image.

texture The way the surface of an object feels, or its depth.

three-dimensional A form that has depth as well as height and width. *A cube is three-dimensional and a square is two-dimensional.*

tone The lightness or darkness of an object. *A yellow book has a lighter tone than a blue book.*

tracing Matching lines or shapes by overlapping them.

vertical Straight up and down. *Telephone poles are vertical.*

volume The amount of air space an object uses.

water-soluble "Runs" when water is added; washable.

zigzag A spiky pattern made by a row of W's attached to one another.

INDEX